Italian Illuminated Manuscripts

IN THE
J. PAUL GETTY
MUSEUM

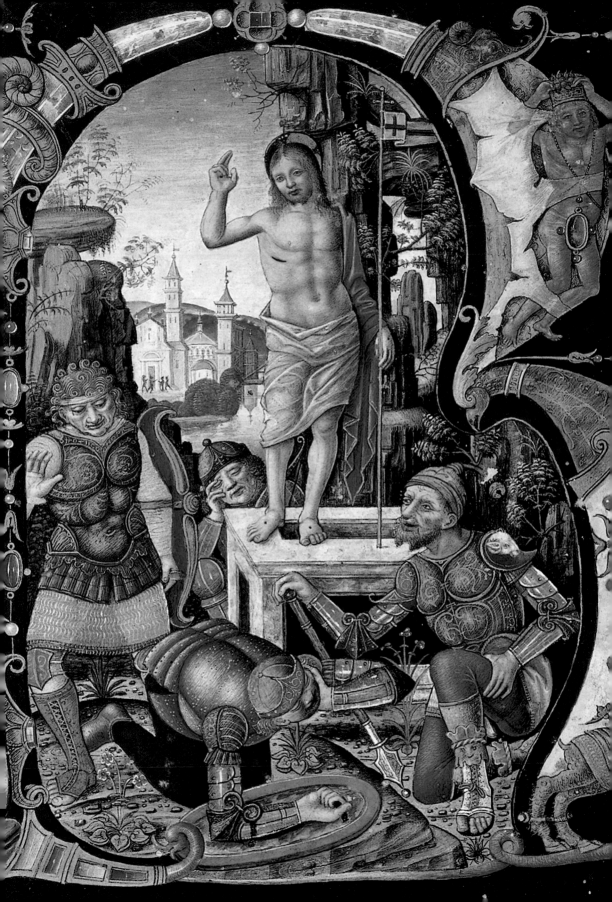

Italian Illuminated Manuscripts

IN THE
J. PAUL GETTY
MUSEUM

Thomas Kren
Kurt Barstow

THE J. PAUL GETTY MUSEUM
LOS ANGELES

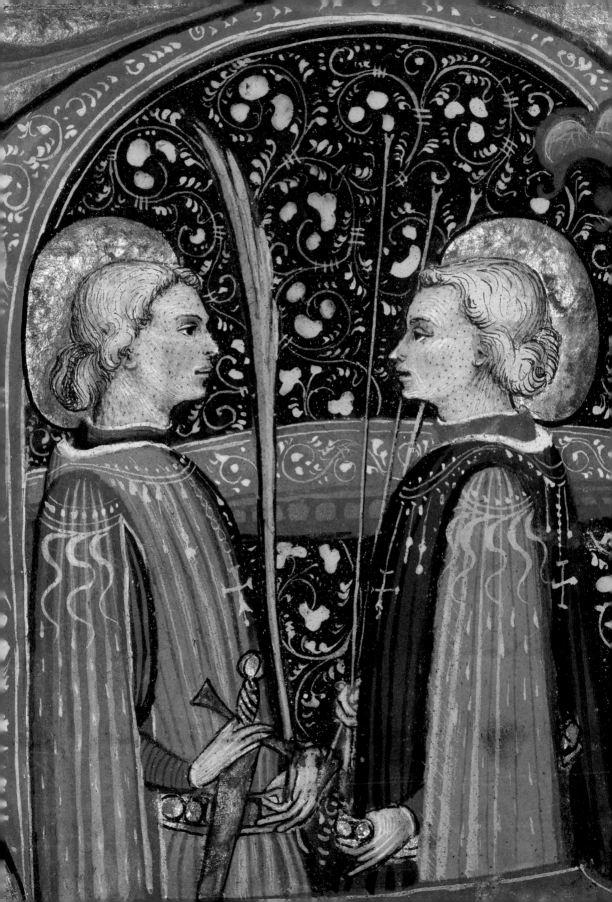

FOREWORD

By far the strongest representation of the art of the Middle Ages in the
J. Paul Getty Museum is its collection of illuminated manuscripts. Illumination forms
a dynamic bridge between ancient and modern traditions of painting at the Getty, the
former through Greek vase painting and Roman wall painting, and the latter through
works on panel and canvas from the early Renaissance to the early twentieth century.
Distinguished by significant holdings in German, French, and Flemish manuscript
illumination, the Getty has made great strides in recent years to become broadly
representative of the major schools of Italian manuscript illumination from both the
Middle Ages and the Renaissance. Italian manuscripts are especially significant as
a complement to our strong holdings of gold-ground and other Renaissance paintings,
because so many artists from the thirteenth century onward worked as both painters
and manuscript illuminators, and the conversation between the two media was often a
lively one.

This volume, reissued in an expanded second edition, belongs to a series
intended to introduce our holdings of illuminated manuscripts by region to a general
audience. Others in the series represent the German, French, and Flemish schools. I would
like to thank Associate Director for Collections Thomas Kren, also the former Senior
Curator of Manuscripts, and Kurt Barstow, former Associate Curator of Manuscripts, for
their vital contributions to the development of the collections as well as for compiling this
volume. The current Senior Curator of Manuscripts, Elizabeth Morrison, is responsible for
several important recent additions to the collection. Christine Sciacca and Bryan Keene
of the Department of Manuscripts assisted with the revisions to this new edition. Kristen
Collins, Erin Donovan, Chris Allen Foster, Stephen Heer, Johana Herrera, Erene Morcos,
Christopher Platts, Michael Smith, Stanley Smith, Ron Stroud, Rebecca Truszkowski,
Nancy Turner, and Rebecca Vera-Martinez helped us to assemble the splendid images
for reproduction. I am also grateful to Elizabeth Nicholson, Jeffrey Cohen, Amita Molloy,
and Miki Bird for producing this beautiful addition to the series.

Timothy Potts
Director

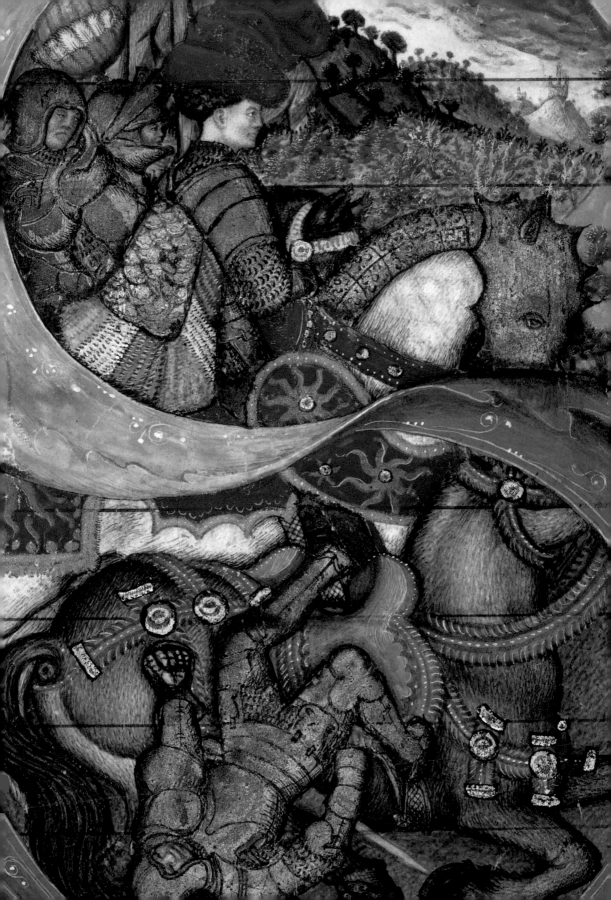

INTRODUCTION

The J. Paul Getty Museum's collection of medieval and Renaissance manuscript illumination is the most recently formed institutional collection of its kind in the United States. It was begun in 1983 with the purchase of the illuminated manuscript holding created by Peter and Irene Ludwig of Aachen, Germany, between 1958 and 1980. The Ludwigs had assembled a comprehensive body of European manuscript illumination that covered the ninth to the twentieth century and many of the great medieval and Renaissance centers of book painting. Their collection included a range of Italian illumination over eight centuries, with such masterworks as the Benedictine breviary from the Abbey of Montecassino; the Bolognese antiphonal by the Master of Gerona; the Ferrarese Gualenghi-d'Este Hours, illuminated by Taddeo Crivelli; and the Roman gradual illuminated by Antonio da Monza for Santa Maria in Aracoeli. From this small but solid foundation, the Museum has built a much larger collection of Italian manuscript illumination that is more representative of the extraordinary achievements of the Italian tradition. Adding for the most part single miniatures and cuttings, due to the exigencies of the marketplace, the total number of works is now nearly sixty. Among the important acquisitions since the purchase of the Ludwig Collection are the Abbey Bible, one of the finest Bolognese Bibles of the thirteenth century (pp. 8–11); three leaves from the Laudario of Sant'Agnese, the most ambitious Florentine manuscript from the first half of the fourteenth century (pp. 22–24); a missal once owned by the antipope John XXIII, from the Bolognese period of the Master of the Brussels Initials (pp. 30–33); and a large decorated initial from the Santa Maria degli Angeli choir books in Florence (p. 42), which was designed by Lorenzo Monaco and carried out by assistants of Fra Angelico. Further additions include individual illuminations by Niccolò da Bologna, Stefano da Verona, Belbello

da Pavia, Giovanni di Paolo, the Master of the Murano Gradual, the Master of the Osservanza, Pisanello, Girolamo da Cremona, Franco dei Russi, Cosmè Tura, the Master of the Dominican Effigies, and Giuliano Amadei.

It must be said that collectors, including those well outside of Italy, have long coveted Italian illumination, certainly from the time of the great Renaissance Hungarian bibliophile Matthias Corvinus (1443–1490). The distinction today of the Italian manuscript holdings of the Bibliothèque nationale de France rests significantly on manuscripts that Charles VIII (r. 1483–98) carried off from Naples and on the great libraries that Louis XII (r. 1498–1515) brought back from Milan in 1499. European admiration for Italian illumination only grew over the centuries. Collectors from the United States, however, did not become seriously involved in purchasing Italian manuscripts until the end of the nineteenth century; since then, they have collected enthusiastically. (The aforementioned missal owned by the antipope John XXIII was in the hands of a Chicago collector by the 1880s.) At the forefront of the Americans was J. Pierpont Morgan (1837–1913), the brilliant financier, art collector, and bibliophile. His library, further developed by his heirs and successive generations of Morgan Library staff members, and made public in 1924, contains the most significant and comprehensive collection of Italian manuscript illumination in the country. In the first half of the twentieth century, the New York Public Library assembled a large collection of Italian manuscripts, with special strength in Renaissance material. And Henry Walters (1848–1931), better known for his French books of hours, also collected Italian manuscripts, which are now in the Walters Art Museum, Baltimore.

Always important for aficionados of Italian illumination, especially since the nineteenth century, has been the availability of leaves and cuttings that originated in Italian books. A famous sale of cuttings from papal manuscripts was organized in 1825 in London by Abate Luigi Celotti (about 1768–about 1846). The works were allegedly removed from manuscripts brought back from Italy as war booty by Napoleon's troops. A hundred years later William Milliken (1889–1978), director of the Cleveland Museum of Art from 1930 to 1958, argued that he could represent Italian regional styles of illumination in a cost-effective way by purchasing manuscript cuttings, a practice that led to the formation of that

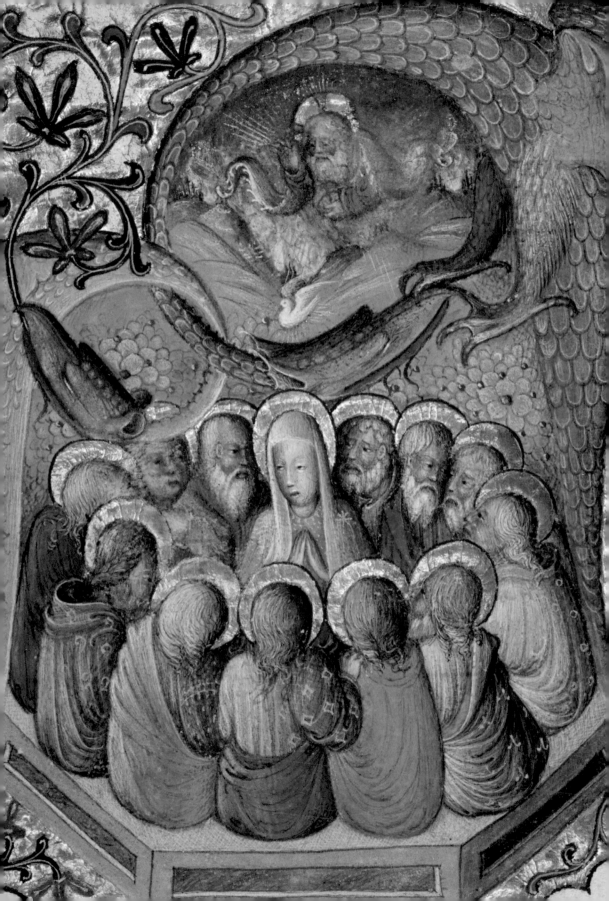

museum's exceptional body of later medieval and Renaissance Italian illumination. Many other American museums have acquired, usually by gift and in the form of cuttings and leaves, one or more noteworthy examples of Italian illumination, including the Metropolitan Museum of Art, the National Gallery of Art, the Saint Louis Art Museum, the Nelson-Atkins Museum of Art, and the Isabella Stewart Gardner Museum, among others. By the 1980s, outstanding Italian leaves and cuttings were more likely to become available than a superb Italian decorated codex.

Some other libraries with collections of Italian illumination are the Free Library and the Rosenbach Museum and Library of Philadelphia, the Lilly Library at Indiana University, and the Houghton Library at Harvard.

The Getty has benefited directly from the American passion for Italian manuscript illumination. Forty percent of its holdings have North American provenance. Moreover, several of the greatest of the American collectors of Italian leaves and cuttings are particularly well represented. There are nine works from the collection of Robert Lehman (1891–1969), who started acquiring Italian illumination and gold-ground painting in the 1920s. Among these are illuminations by Pacino di Bonaguida, Belbello da Pavia, Stefano da Verona, Franco dei Russi, and Cosmè Tura (pp. 22, 45, 48–49, 50, 51, 65, 75, 79, 91). The German book dealer Bernard Breslauer (1918–2004) was settled in New York when, during the 1970s and 1980s, he created a major personal collection of illuminated leaves and cuttings. From this collection the Getty was fortunate to acquire key Italian examples, including works by the Master of the Dominican Effigies, Franco dei Russi, Niccolò da Bologna, Francesco d'Antonio del Chierico, and Vincent Raymond, along with the aforementioned choir book cutting from Santa Maria degli Angeli in Florence (pp. 23, 28, 42, 47, 71, 90).

Manuscripts are integral to the cultures that produced them and reflect their artistic and intellectual environments and significant historical events of their times. Equally important, manuscript illumination represents a unique artistic medium with its own tradition. The illuminations in this volume span eight centuries, representing a dramatic evolution of visual styles. Although this book begins with objects produced in monastic scriptoria and ends with missals made by secular artists, all of the works show a family resemblance. For whether they depict

scenes from the life of a newly popular saint, such as Saint Dominic or Saint Francis; are products of the Italian fifteenth-century movement known as Humanism; or are recognizable examples of the schools of Renaissance painting styles peculiar to Florence and Padua in the fifteenth century and Rome in the sixteenth century, all of these illumi-nations were originally in books and therefore viewed within the context provided by words, prayer, and ritual. Not only can some of the works included here be counted among the finest and most creative examples of Italian painting, all of them—from illumination in hagiographies to fighting manuals, from books made for private devotion to those made for public ceremony—extend our conception of the range, contexts, and meanings of visual imagery within Italian culture. This is especially true for the later period of the fourteenth through the sixteenth century, for which our sense of the period's painting has been informed almost exclusively by monumental frescoes as well as by panels.

 The earliest medieval examples included in this volume are a leaf from a psalter and a breviary—the two books most important for the daily round of monastic devotions—decorated with large, interlace initials marking the beginning of important texts. The sacred word is here embellished, humbly on the ninth-century psalter page (p. 1), which contains the hymn ascribed to Saint Ambrose and Saint Augustine, "Te Deum laudamus" (We praise you, O Lord); and more ornately in the twelfth-century breviary made in Montecassino, the heart of Benedictine monasticism (pp. 2–6). Just as the word must be considered in these works as something visual, to be seen as well as heard, imagery in manuscripts must be perceived within an oral and textual framework that informs its meaning and reception.

 We might examine, in terms of the relationship between text and image, two nearly contemporaneous illuminations that portray the two most important founders of new monastic orders in the thirteenth century: Saint Dominic (about 1170–1221), who founded the Order of Preachers (Dominicans); and Saint Francis (1181–1226), who founded the Order of Friars Minor (Franciscans). The initial *M* with the death of Saint Dominic (p. 12) comes from a Bolognese choir book and accompanied the text that would have been sung on the feast of Saint Dominic. The visual marker of this chant is a complex of layered imagery rather than a single

narrative event. First of all, we see Saint Dominic on a funeral bier with members of his order gathered around. Above, his soul (represented as a small figure of Dominic) is pulled up into heaven by Christ and the Virgin, the part of the scene that derives from a vision of one of the early Dominican brethren, Fra Guala of Brescia. Below, we see the infirm gathering around the body of Dominic, a scene meant to convey the miraculous healing powers of the saint's remains. And, finally, in roundels at the four corners, Dominican friars are seen in different gestures of prayer. These figures may represent the contemporary audience—the Dominican friars who used the choir book and sang praise to their founder on his feast day. Likewise, the initial *G* with the stigmatization of Saint Francis (p. 13) by Rinaldo da Siena complements the text for his feast day. The story related is the moment when Francis, meditating on the Crucified Christ, has a vision of Christ on the cross surrounded by seraphic wings. The saint is so moved that his body takes on the very wounds (stigmata) of Christ. The vision is cleverly integrated with the letter, for it seems to originate behind the cross and the letter itself, in three bands colored in soft shades of blue, while the wings overlap the front of the letter. The birds deployed around the saint make reference to the famous story of Saint Francis preaching to the birds, which here seem disturbed, some of them ruffling their feathers as if they have noticed the apparition above. Their attentiveness to Francis and this event also reminds one of the first word of the chant, "Gaudeamus" (Let us give praise).

The close relationship between text and image in a choir book from this period also may be seen in one of the finest miniatures in the Getty collection (pp. 16–17). In *Christ in Majesty* in an initial *A*, from a Bolognese choir book, the Master of Gerona uses a number of means to create an especially forceful, dynamic physical presence of Christ, from the crowded angels bursting out of the letter form, to Christ's crisply modeled robe and piercing gaze, to the projecting footstool in front of the sculptural throne. The text of the chant, as it happens, is devoted precisely to the physical presence of Christ in the world. The miniature complements the first long chant sung on the first Sunday of Advent, the season of preparation for Christmas. The chant uses words from Isaiah (the prophet pictured in the roundel at the bottom of the initial): "Aspiciens a longe ecce video dei

potentiam venientem" (Behold, from afar I see the coming power of God), which were thought to foretell the Second Coming of Christ.

Manuscript painting in Italy was shaped not only by its particular context within a book but also by diverse regional traditions and differing circumstances of production. In the medieval period, more specifically the thirteenth and fourteenth centuries, Bologna became both a major university town and an important locus for the Dominican order (Saint Dominic is buried there). Thus it also became a major center for the making of manuscripts, especially books for scholarly study, but also those associated with the Dominicans. The latter is exemplified by the cutting from a choir book discussed above (p. 12) and also by the magnificent Abbey Bible, with playful marginalia, which opens with a two-page display that pairs the Creation of the World with expressive scenes from the Life of Christ (pp. 8–11). Bolognese illumination continued to thrive in the fourteenth century, which witnessed a new, exciting, almost restless style, practiced distinctly by several artists. One of them, the Illustratore, created a miniature teeming with activity— harvesting grapes, collecting fruit from a tree, milking a cow, crushing grapes—that illustrates a section discussing agriculture in Justinian's *New Digest*, an important textbook of Roman civil law first codified in the sixth century (pp. 26–27).

The greatest Bolognese illuminator of this period was Niccolò da Bologna, whose massive but sensitively painted Saint Dominic decorates a folio from a register of the Shoemakers' Guild (p. 28). All the guild members from the neighborhood of San Procolo are listed next to the figure of the saint, with notations made next to their names when they died. A more exuberant scene—of Pentecost, in an initial from a choir book (p. 29)—provides us with an example of Niccolò's lively, compacted narrative imagery. The most significant manuscript in the collection from this period, however, was illuminated by a student of Niccolò, known as the Master of the Brussels Initials. This artist began his career in Bologna and later moved to Paris, the other great university town of the day. While still in Italy, he was employed to illuminate a missal (pp. 30–33) for Cardinal Cosimo de' Migliorati, who later became Pope Innocent VII. The manuscript was subsequently owned by the antipope John XXIII, whose arms and papal tiara are painted over the original arms. The illumination in this manuscript is notable

for the exceptional inventiveness of the marginalia and its animated scenes, but it is also worth commenting on the creative use of gold. In *Christ in Majesty* (p. 30), the foliate background, the halos of Christ and the angels, and the rays between Christ's body and the mandorla in which he sits, not only activate the scene but also help define the different planes in which the various parts of the picture are located. In *The Elevation of the Host* (p. 31), gold helps to register the ceremonial richness of the liturgy. The stars in the vaults are all done in gold, and real light catching them on the page makes them shimmer just as they must have in the vaults of contemporary churches.

Unlike their counterparts in Bologna, who tended to specialize in illumination, artists in Florence and Siena often practiced in other media as well. Pacino di Bonaguida (pp. 22, 24), the Master of the Dominican Effigies (p. 23), Lippo Vanni (p. 25), Lorenzo Monaco (p. 42), the Master of the Osservanza (p. 43), and Giovanni di Paolo (p. 44) were all panel painters, too. The most prolific of these illuminators, Francesco d'Antonio del Chierico (pp. 68–69, 70–71), was also a goldsmith. Pacino, the lead illuminator of the afore-mentioned Laudario of Sant' Agnese, was a great storyteller in the tradition of his contemporary Giotto. The Compagnia di Sant'Agnese in Florence consisted of pious laypeople who met as a group to sing and worship together in Santa Maria del Carmine, the church where Masaccio was much later to paint the famous Brancacci Chapel. In 2003, 2005, and 2006, the Getty acquired three distinct leaves from this laudario serendipitously, each from a different owner. The last two are by Pacino (pp. 22, 24). The Master of the Dominican Effigies painted the first, *Pentecost* (p. 23), with its brilliant array of colors—from intense lime greens to several shades of blue—and the grand facade of the tabernacle projecting in front of the frame. A miniature (p. 42) from another famous choir book, a gradual made for the Camaldolese monastery of Santa Maria degli Angeli, presents an interesting case, for the scene was designed by the most talented illuminator/painter of the late medieval school of painting in Florence, Lorenzo Monaco, and was finished by artists in the circle of Fra Angelico, one of the most innovative artists of the early Renaissance. Emblematic of the distinctions between the two periods within the miniature are two figures, that of Christ, whose robe is constructed as if it has been cast in bronze by an artist

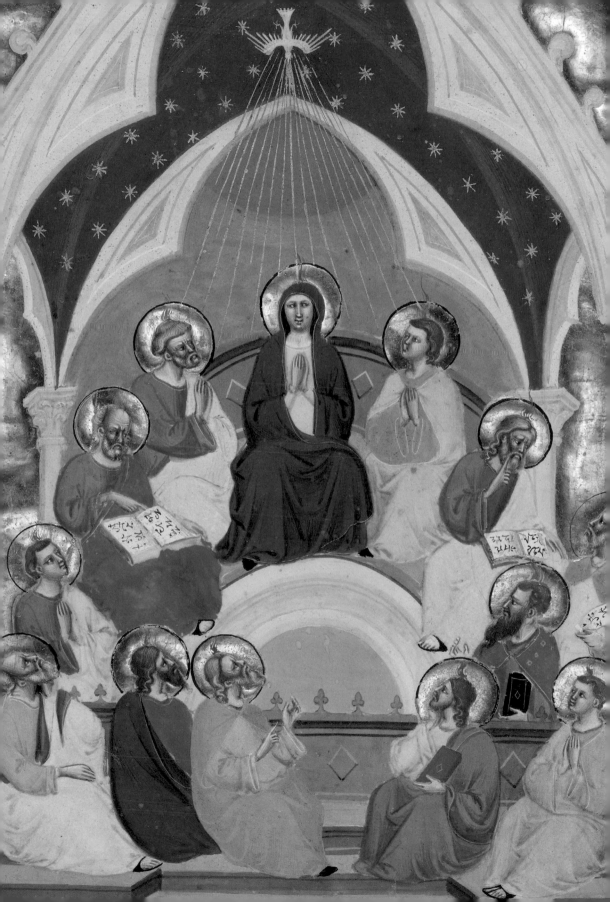

imbued with the aesthetics of the International Gothic, and that of the angel directly to his left, whose upright bearing and clearly defined ringlets of hair are characteristically Renaissance.

Only two manuscripts (pp. 66–67, 68–69), however, both made in Florence, might be called Humanist in the strict sense of that word, Caesar's *Commentary on the Gallic Wars* and Lactantius's *Divine Institutions*. Both are ancient texts of the sort Humanist scholars were interested in; both contain Roman capital letters and Humanistic script, which was derived from Romanesque manuscripts and, ultimately, from Carolingian manuscripts that were thought to be ancient; and both contain the "white vine" border decoration that was imitated from earlier manuscripts and was also thought to be from antiquity.

Another group of manuscripts was produced in the courts of northern Italy or by illuminators who worked at those courts, often moving between them. Expressive of the chivalric ethos of those courts is a manual on combat, *The Flower of Battle*, one of several versions of a manuscript produced for the marquis of Ferrara, Niccolò III d'Este (pp. 37–39). The book illustrates the moves and countermoves that would be made during different combat situations and with different weapons. While the drawings that accompany the text are not exceptional for their artistic quality, they attempt to convey to the reader the specificity of tactical maneuvers in the field. One of the great artists to express in visual terms the courtly chivalric splendor that so enthralled the ruling princes of Italy was Pisanello, who worked for the Visconti in Milan, the Este in Ferrara, the Gonzaga in Mantua, and the Aragonese rulers of Naples. A miniature partly executed by him, originally in a choir book and illustrating the feast of the Conversion of Saint Paul, depicts Paul, clad in Renaissance armor, falling off his horse on the way to Damascus (pp. vi, 46). In the top half of the initial, however, a prince, wearing a flamboyant red cap of the sort then in fashion, is shown with a small retinue of soldiers. The colors of one soldier's plume and the prince's cape can be associated with the heraldry of either the Este or Gonzaga families, both of whom were patrons of Pisanello. The reason for this prince's appearance in a putatively sacred scene is not yet known. He was probably the patron of the manuscript to which this cutting belonged, and perhaps the feast of the Conversion of Saint Paul held

some special significance for him.

Three of the artists who might be considered under this grouping of court illuminators—Taddeo Crivelli (pp. 56–57, 58, 60–64), Franco dei Russi (pp. 47–51), and Girolamo da Cremona (p. 52)—all worked on one of the most lavish and expensive manuscript commissions of the fifteenth century, the Bible of Borso d'Este (Modena, Biblioteca Estense). The Ferrarese Crivelli and Franco dei Russi headed the project, and the younger Girolamo da Cremona was brought in later. Crivelli's masterpiece on a small scale, the Gualenghi-d'Este Hours (pp. 58–64), was made on the occasion of the marriage of Orsina d'Este, a member of Ferrara's ruling family, to Andrea Gualengo, a senior adviser, diplomat, and member of a long-standing family of councillors to the Este. Crivelli's art is dependent in many ways on the two greatest court artists of the fifteenth century, Pisanello and Andrea Mantegna. Despite their diminutive size of just over four inches tall, the folios in the Gualenghi-d'Este Hours are large in invention and energy that is expressive of their devotional content.

The versatile Franco dei Russi contributed to another of the most ambitious manuscript projects of the century, the series of choir books commissioned by the Greek Cardinal Bessarion (about 1399/1408–72), originally intended for the Franciscan convent of Saint Anthony of Padua in Constantinople. (The books never left Italy due to the fall of the city in 1453.) Three leaves from the Bessarion choir books, ascribed to Franco dei Russi and now in the Getty collection, offer the full range of his painting styles and probably reflect the slow gestation of the illumination of the set's roughly twenty volumes (pp. 48–51).

After working on the Bible of Borso d'Este, Girolamo was recommended to the Mantuan court by its newly appointed artist, Mantegna. The itinerant Girolamo's *Pentecost* (p. 52) was likely made during this Mantuan period, for it closely resembles, in feeling and format, paintings executed by Mantegna for the Gonzaga Chapel. Here Pentecost takes place in the stilled and majestic setting of a Renaissance palace with contemporary window frames and book bindings. The Holy Spirit—the dove suspended in the middle of the room—casts a supernatural golden light, which bathes the wall and contrasts with the natural light of the world seen through the window, where an ordinary bird is perched on the branches

of a decorative bush.

Lombardy, a province that was largely under the rule of the dukes of Milan, maintained its own artistic traditions, rather more conservative for much of the fifteenth century than the new Renaissance styles of Padua and Florence. A charming, courtly example of Lombard illumination at the turn of the century may be found in a little booklet relating the story of two local saints, Aimo and Vermondo. In one scene we see the two youths, dressed in refined, costly costume, hunting boars (p. 34). When the boars turn on them, the pair are saved by the Virgin and end up founding a church, performing miracles, and developing a cult following. By the time of their deaths, they were regarded as saints.

Even at midcentury the art of the Olivetan Master, one of the major shapers of the Lombard tradition, was still imbued with the graceful ideals of the International Gothic. His *Four Saints* in an initial *B*, a cutting from a choir book, contains figures with elongated hands and faces and voluptuous robes that curve around in calligraphic decoration (p. 74). The subtle distinctions in gesture and facial expression of each individual saint, combined with the figures' tight-knit identity as a group, make this miniature one of the master's most intimate and moving. The Master of the Murano Gradual, among the most inventive illuminators of fifteenth-century Italy, likely worked under Belbello da Pavia (p. 75), the major artist of the famous Visconti Hours (Florence, Biblioteca Nazionale), although he later worked in the Veneto. His *Saint Jerome Extracting a Thorn from a Lion's Paw* (p. 72) combines a poignant narrative with an exuberant design. The brave Jerome comes to the aid of the suffering beast by extracting the thorn; the monk nearby appears anxious for Jerome's safety, even as the lion conveys his relief. The sweeping curves of both Jerome's black robe and the folds of his massive blue-and-red mantle unite rhythmically with the scalloped contours of the frame.

The two miniatures by Bartolomeo Gossi da Gallarate (pp. 76–77), made for a Carthusian choir book perhaps originally in the collection of the Certosa of Pavia, are not so different in style from the Olivetan Master's miniature. Facial types are similar, and the hands do much of the work of communicating interior states of mind. Particular to Gossi, however, is the dramatic play of color and light. The foreground of rose and blue in both, as well as the aggressive lemon yellow of the

rock in *The Women at the Tomb*, lends these miniatures an unreal quality. At the same time, the soft, subtle play of light on the hills in the background of both miniatures is obviously based on observation.

Lombard art changed when Leonardo da Vinci came to the Milanese court, and this is registered in the art of the illuminator called Master B.F. In both *Noah Directing the Construction of the Ark* and *Saint John the Evangelist* (pp. 82–83), the facial types reflect the painting style of Leonardo. The loose, painterly handling of this scene marks a dramatic change from the world of the Olivetan Master and Gossi, introducing a new artistic direction in the sixteenth century.

At this time Rome became a significant center of artistic patronage, inspiring a number of illuminators to relocate there. Of the Getty's holdings in sixteenth-century Italian manuscripts, four of the five are Roman (pp. 85, 86–89, 90, 91). The massive choir book for the Franciscan church of Santa Maria in Aracoeli in Rome was illuminated by Antonio da Monza, a Milanese artist, and is the largest book in the Getty collection. The most magnificent page from this manuscript, adorning the chant for the feast of the Resurrection (p. 85), is in many ways a product of the artistic vocabulary of the High Renaissance applied to sacred subject matter. The type of Christ, both in the initial and at the bottom of the page, is derived from Leonardo, as are the winged putti. The decorations in the letter and borders include antique cameos and jewels, as well as a type of motif known as *grotteschi*, drawn from the recently excavated Golden House of Nero. Indicative of the confrontation between the Classical and the Christian is the pairing of Saint Sebastian, studded with arrows and seen through glass in the stem of the letter *R*, with a cameo of Apollo below. The same heroic body type is employed in both figures, as well as in the central figure of Christ rising from his tomb.

Matteo da Milano, another artist originally from Milan, worked for many of Italy's ruling families, including the Medici and the Este. By the second decade of the sixteenth century he was in Rome working on manuscript commissions for popes and cardinals. A missal made for a member of the Orsini family (pp. 86–89) contains borders of jewels, cameos, and hybrid figures in an *all'antica* style, a trademark of Matteo's manuscripts. Characteristic of his precise painting and taste for exotic costume is the figure of King David (pp. 88–89) emerging from the letter

A that begins the text for the first Sunday of Advent, "Ad te levavi animam meam" (I lift up my soul to you), words from one of the psalms of which David was thought to be the author. Finally, the Christ of *The Crucifixion* (p. 90) that once belonged to a missal probably made for Pope Paul III and painted by the papal illuminator Vincent Raymond adopts the bulky, heroic male nude–type of Michelangelo and sets the cross in front of an extensive landscape. Surrounding this recognizably Renaissance image are fragments of the text for the Feast of the Exultation of the Holy Cross (at top: "You who suffered for us, O Jesus Christ, have pity on us"). Just as in the earliest decorative imagery we have examined in medieval manuscripts, figural imagery in this Renaissance illumination is not viewed in isolation but filtered through the context of words.

While Italian manuscript illumination is less known than other genres of painting, it played a prominent role in Italian art and culture of the Middle Ages and Renaissance. Costly to produce and labor intensive, illuminated manuscripts were highly valued relative to other sorts of painting. The Bible of Borso d'Este, mentioned above, for example, cost much more than the famous astrological frescoes in the Palazzo Schifanoia in Ferrara. Because of the considerable variety of texts that were illuminated—for the liturgy and for private devotion, for theology and the study of history, for pleasure and practical instruction, and for propaganda—manuscripts provided unrivaled opportunities for the invention of new imagery. Works of history, religion, music, myth, hagiography, literature, archaeology, philosophy, and science have come down to us in illuminated copies. More than any other medium, manuscripts provide us with subject matter that is not to be found elsewhere. There are more extensive cycles of the Bible and the *Aeneid* in manuscripts, for example, than in any other painted medium. Thus manuscript illumination reveals myriad facets of the Italian-speaking cultures of the Middle Ages and Renaissance, and it does so in profound, powerful, and often moving ways.

Thomas Kren, *Associate Director of Collections*

Kurt Barstow

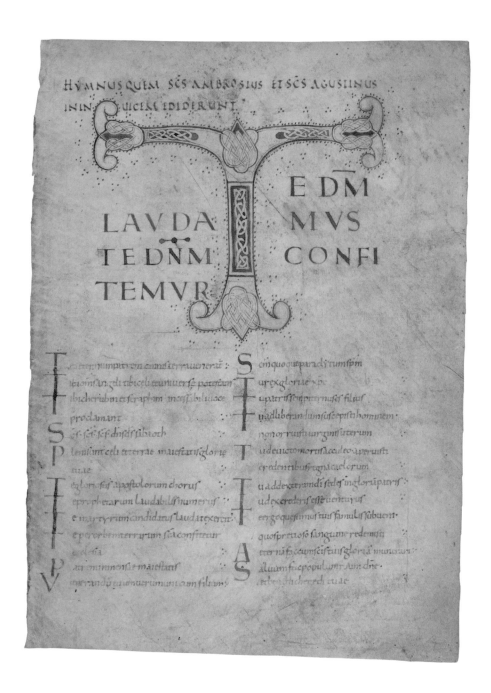

Decorated Initial T

Leaf from a psalter, recto
Northern Italy, third quarter
of the ninth century
Leaf: 30.3 × 21.3 cm (11^{15}⁄₁₆ × 8⅜ in.)
Ms. Ludwig VIII 1; 83.MK.92

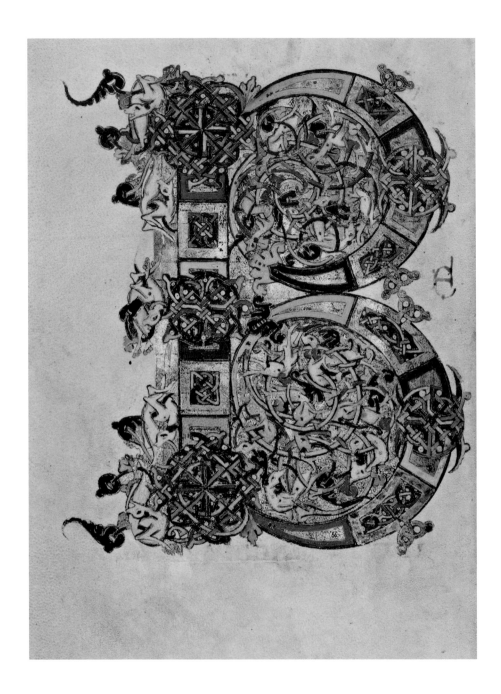

Inhabited Initial B

Montecassino Breviary, fol. 140v
and detail
Montecassino, 1153
Leaf: 19.2 × 13.2 cm (7⁹⁄₁₆ × 5³⁄₁₆ in.)
Ms. Ludwig IX 1; 83.ML.97

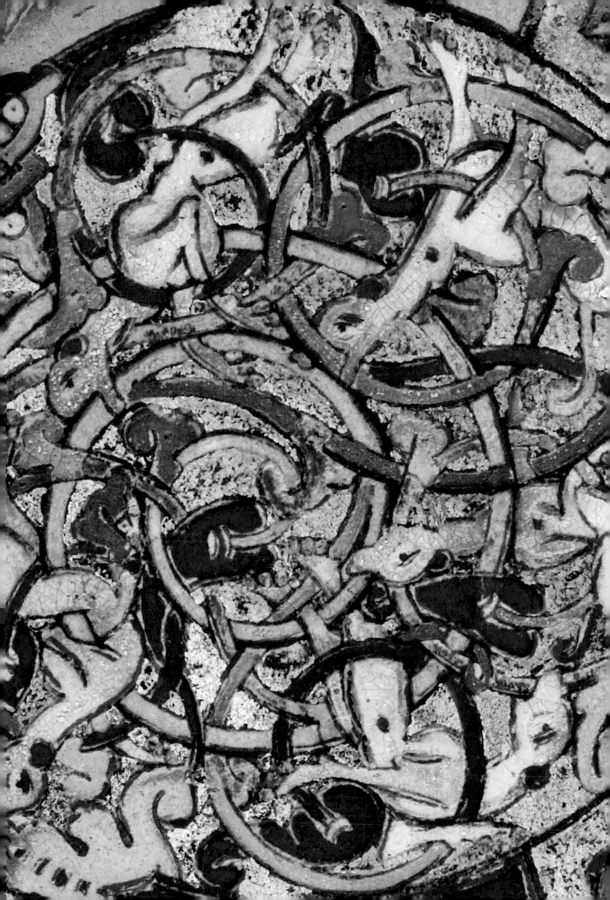

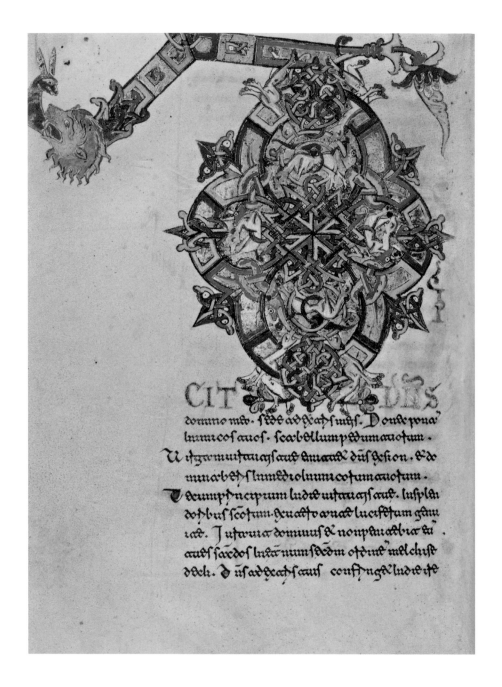

Inhabited Initial D

Montecassino Breviary, fol. 212v

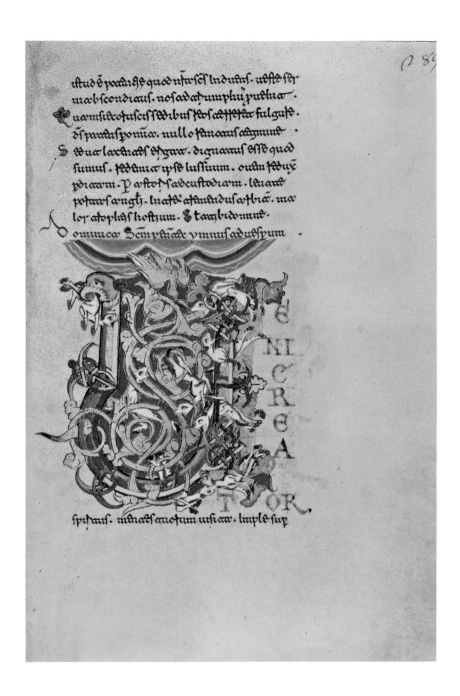

Initial V: The Descent of the Holy Spirit

Montecassino Breviary, fol. 289

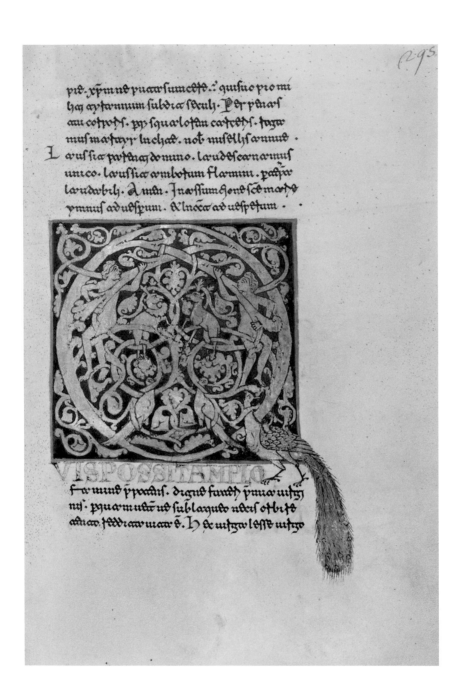

Inhabited Initial Q

Montecassino Breviary, fol. 295

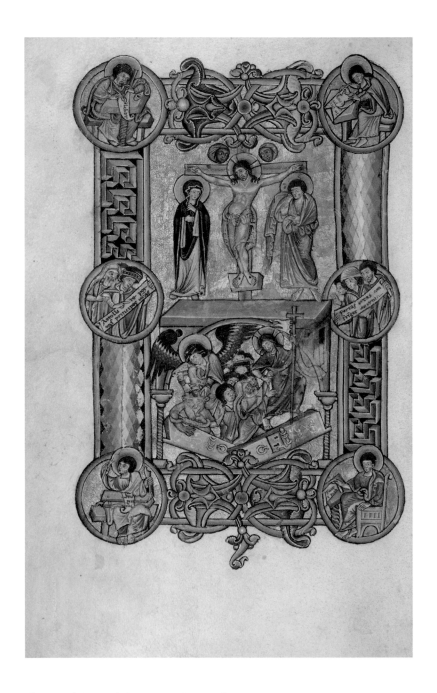

The Crucifixion and the Descent into Limbo

New Testament, fol. 191v
Sicily, late twelfth century
Leaf: 24.6 × 16.2 cm (9¹¹⁄₁₆ × 6³⁄₈ in.)
Ms. Ludwig I 5; 83.MA.54

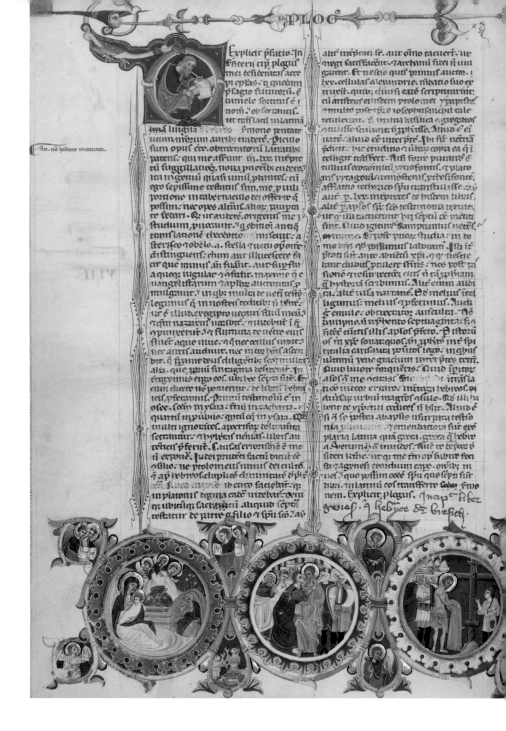

Initial D: Saint Jerome with Scenes from the Life of Christ

Abbey Bible, fol. 3v
Bologna, about 1250–62
Leaf: 26.8 × 19.7 cm (10 9/16 × 7 3/4 in.)
Ms. 107; 2011.23

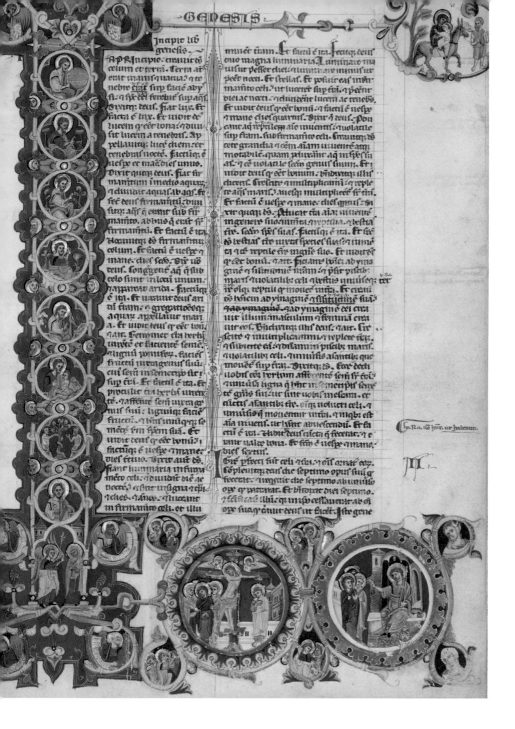

Initial I: Scenes of the Creation of the World and the Life of Christ

Abbey Bible, fol. 4

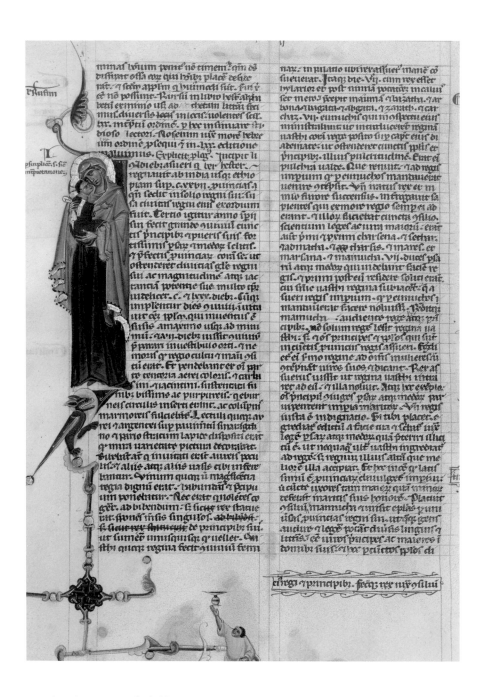

Initial I: The Virgin and Child

Abbey Bible, fol. 194v and detail

mmas loium pqne nõ timem̃? qm dz
diſſipat oſſa eoȝ qui hõibꝫ placẽ deſide
rac. 7 ſcdm applm q̃ ḃmiliati ſũt. ſm̃ ɫ
cē nõ poſſunt. Rurſu͂ m libio belſabeth
beth exemio uſq̃ ad thetam l̃itaȝ feci
mus dineꝛſis locis in locis. uolentes ſcal̃
teȝ. meptũ oȝdinẽ. ꝓ hec inſinuare ſtu
dioſo lectoȝ. Nos em̃ iuxta moȝe hebre
um oȝdinẽ ꝓſequi 7 in .lxx. editione
tr̃aulimus. Explicit ꝓlǵ. Incipit li
Adiebꝰ aſueri q̃ ɫ xeſter.
regnanit ab india uſq̃ ethio
piam ſup. c. xxvij. ꝓuincias a
qn ſedit in ſolio regni ſui. ſu
ſa cinitas regni eius exordium
fuit. Tercio igitur anno ıp̃i
ſui fecit grande qnuiuiu͂ cunc
tis ꝑncipibꝫ 7 pueris ſuis foȝ
tiſſimis ꝑſaȝ 7 medoȝ ſeltis.
7 ꝓfectis ꝓuinciaȝ coȝa ſe. ut
oſtenderet dinitias gl̃e regni
ſui ac magnitudine atꝗ; iac
tanciaȝ potentie ſue. multo tp̃ȝ
uidelicet. c. 7 lxxx. diebꝫ. Cu͂q;
implentur dies qnuiuij. inuta
uit cõ ꝓpl̃ȝ. qui inuentus ē
ſuſis a maximo uſq; ad mini
mu͂. 7 vij. diebꝫ iuſſit qnuiuiu͂
ꝓparari in ueſtibulo oȝti. 7 ne
moȝis qꝝ regio cultu 7 maũ q̃ſi
ti erat. Et pendebant ex õi ꝑ
te tentoȝia aerei coloȝis. 7 carbu
ſini. 7 iacintini. ſuſtentata fu
nibꝫ biſſinis ac purpureis. q̃ ebur
neis circulis inſerti erant. ac coli͂pnis
marmoȝeis fulciebãt. Lectuli quoꝗ; au
rei 7 argentei ſup pauimentu ſmaȝagdi
no 7 paȝio ſtraticu͂ lapide diſpoſiti erant
qꝝ multa uarietate pictura decoȝabat.
Bibebãt aũt q̃ inuitati erãt aureis pocu
lis. 7 aliis atꝗ; aliis uaſis cibi inferre
bantuȝ. Vinum quoꝗ; ut magnificentia
regia dignu͂ erat. abundãt 7 ꝓcipu
um ꝓnebatur. Nec erat qui nolentes

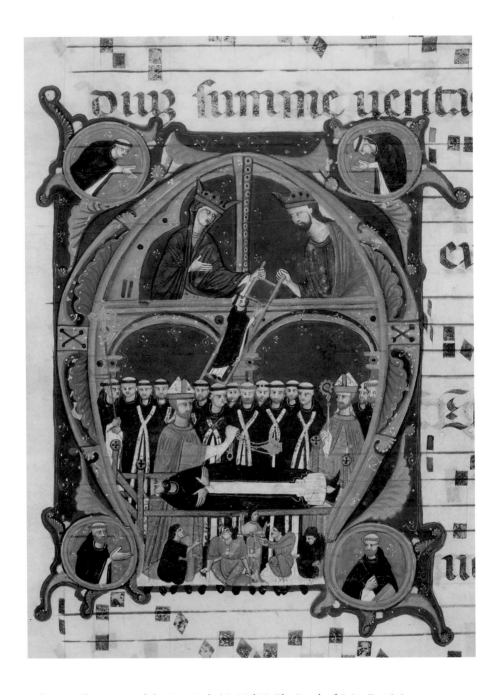

Bolognese Illuminator of the First Style | Initial M: The Death of Saint Dominic

Leaf from an antiphonal, recto (detail)
Bologna, about 1265
Leaf: 52.5 × 37.3 cm (20^{11}/$_{16}$ × 14^{11}/$_{16}$ in.)
Ms. 62; 95.MS.70

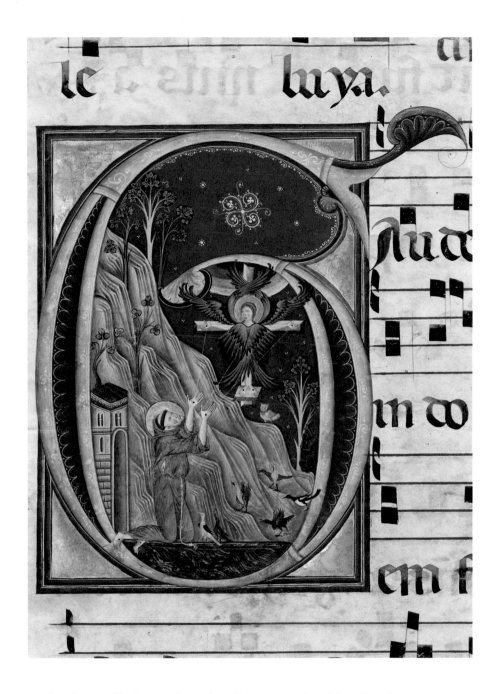

Attributed to Rinaldo da Siena | Initial G: The Stigmatization of Saint Francis

Leaf from a gradual, verso (detail)
Siena, about 1275
Leaf: 52.9 × 37.2 cm (20¹³⁄₁₆ × 14⅝ in.)
Ms. 71; 2003.15

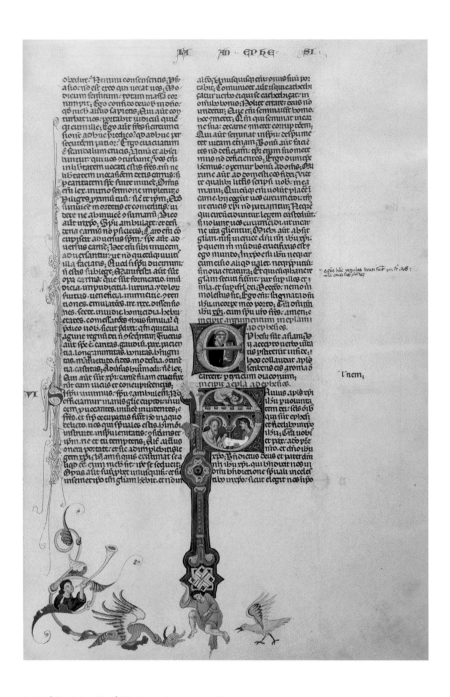

Initial P: Saint Paul Giving a Letter to a Messenger

Bible, fol. 499
Bologna, about 1265–80
Leaf: 37.5 × 24.8 cm (14¾ × 9¾ in.)
Ms. Ludwig I 11; 83.MA.60

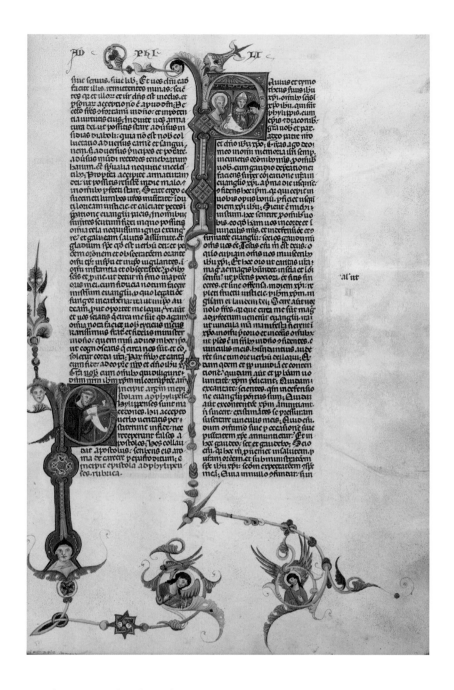

Initial P: Saint Paul with a Bishop Giving a Letter to a Messenger

Bible, fol. 501

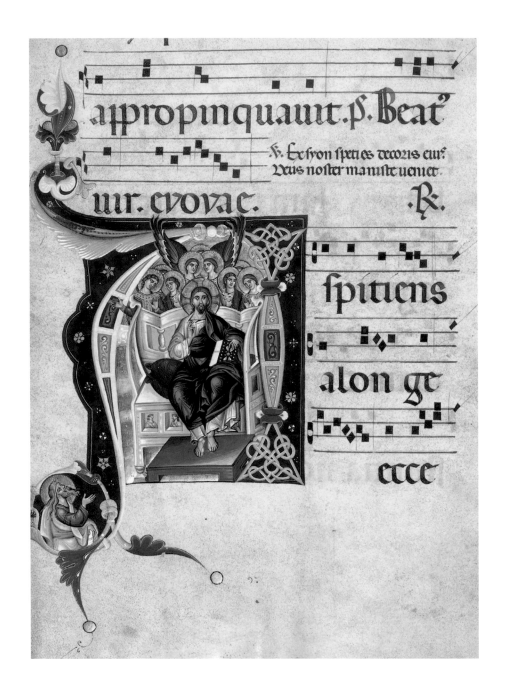

Master of Gerona | Initial A: Christ in Majesty

Antiphonal, fol. 2 and detail
Bologna, late thirteenth century
Leaf: 58.3 × 40.2 cm (22¹⁵⁄₁₆ × 15¹³⁄₁₆ in.)
Ms. Ludwig VI 6; 83.MH.89

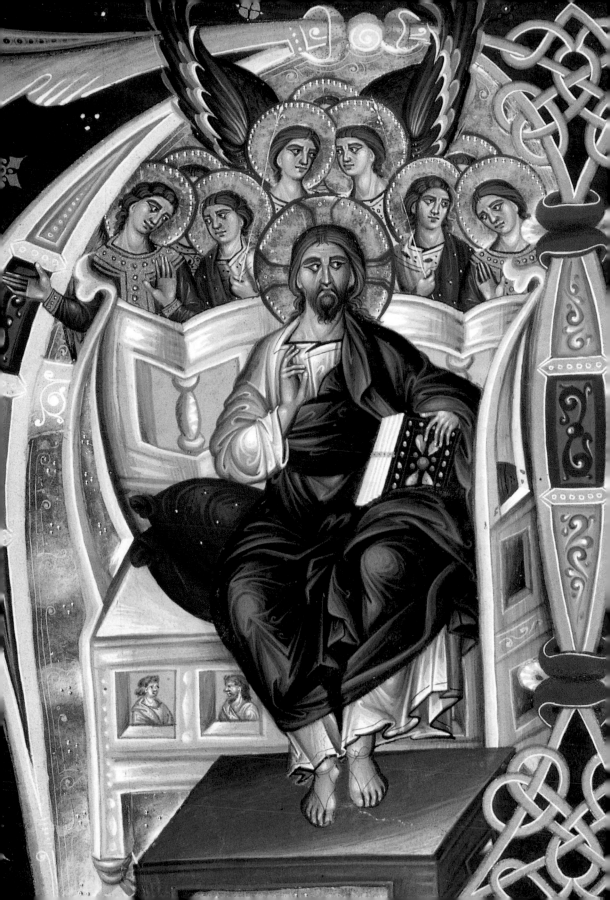

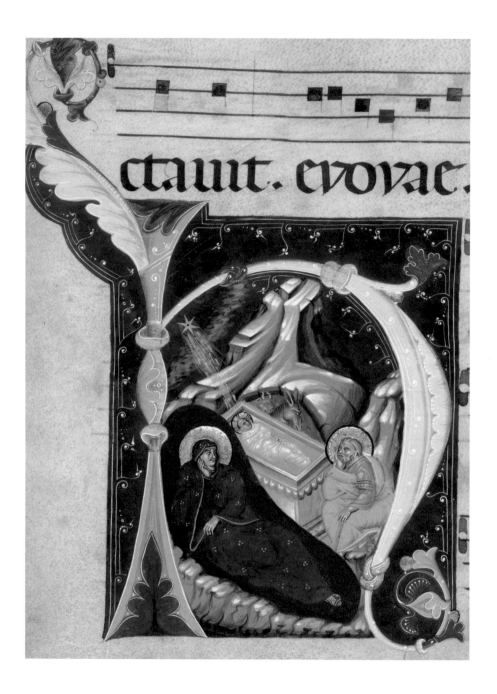

Master of Gerona | Initial H: The Nativity

Antiphonal, fol. 94 (detail)

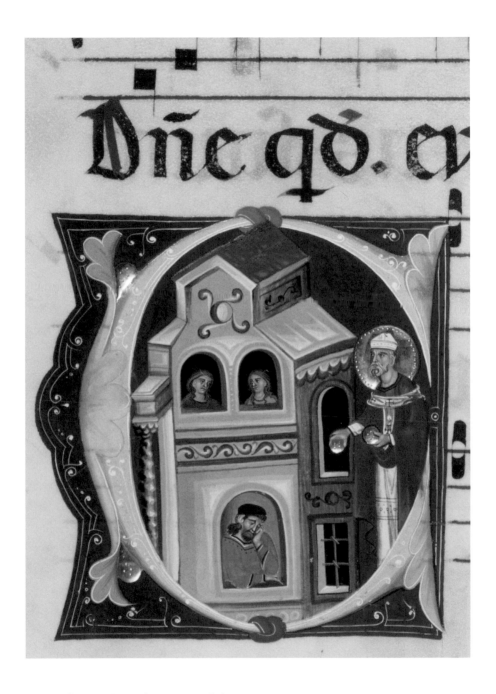

Master of Gerona | Initial C: Saint Nicholas

Antiphonal, fol. 171v (detail)

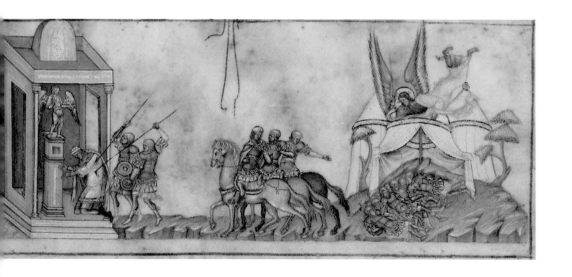

The Assassination of Sennacherib

Cuttings from a book of
Old Testament prophets, leaf 1
Sicily, about 1300
Cutting: 7.3 × 16.5 cm (2⅞ × 6½ in.)
Ms. 35; 88.MS.125

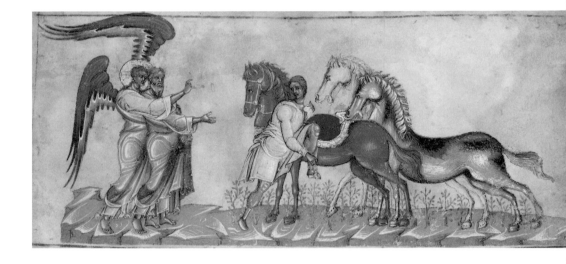

The Vision of Zechariah

Cuttings from a book of
Old Testament prophets, leaf 2
Cutting: 7.3 × 17.5 cm (2⅞ × 6⅞ in.)

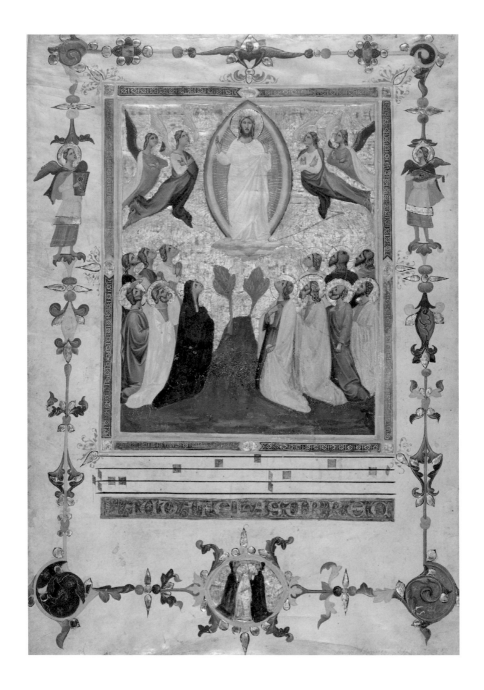

Pacino di Bonaguida | The Ascension

*Leaf from the Laudario of Sant'Agnese,
verso*
Florence, about 1340
Leaf: 44.4 × 31.8 cm (17½ × 12½ in.)
Ms. 80a; 2005.26

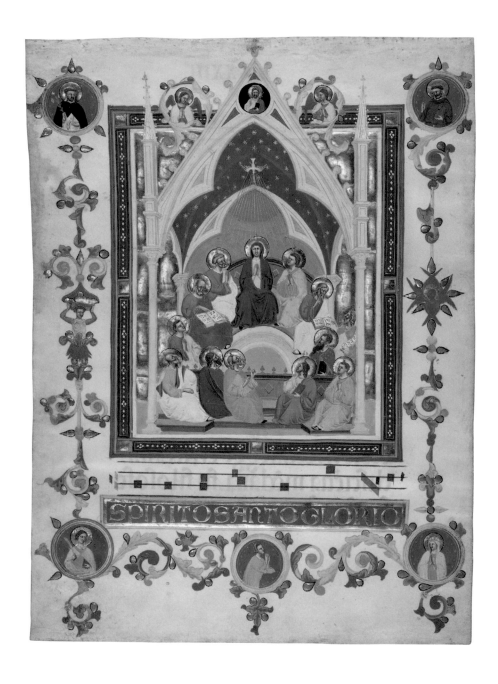

Master of the Dominican Effigies | Pentecost

Leaf from the Laudario of Sant'Agnese,
verso
Leaf: 43 × 31.7 cm (16¹⁵⁄₁₆ × 12½ in.)
Ms. 80; 2003.106

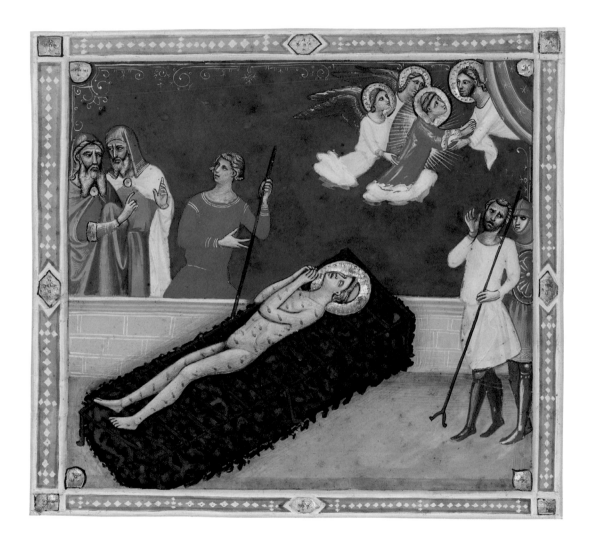

Pacino di Bonaguida | The Martyrdom of Saint Lawrence

*Cutting from the Laudario
of Sant'Agnese, verso*
Cutting: 19 × 20.8 cm (7½ × 8³⁄₁₆ in.)
Ms. 80b; 2006.13

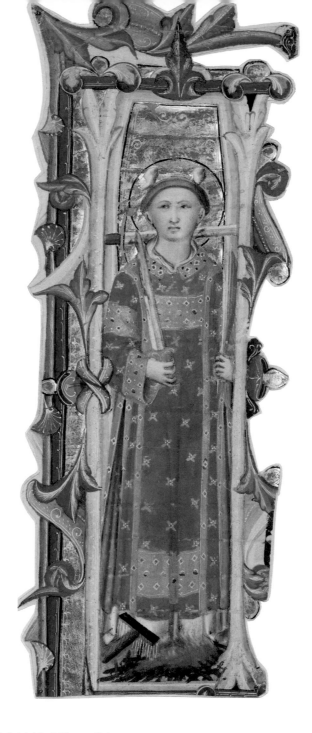

Lippo Vanni | Initial I: A Martyr Saint

Cutting from an antiphonal, recto
Siena, third quarter of the
fourteenth century
Cutting: 30.2 × 11.4 cm (11⅞ × 4½ in.)
Ms. 53; 93.MS.38

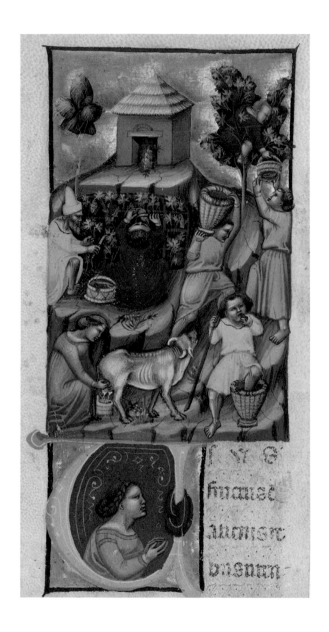

Attributed to the Illustratore | Harvest Scene

Cutting from Justinian, New Digest
(Digestum novum), *verso, and detail*
Bologna, about 1340
Cutting: 14.4 × 7.6 cm (5¹¹⁄₁₆ × 3 in.)
Ms. 13; 85.MS.213

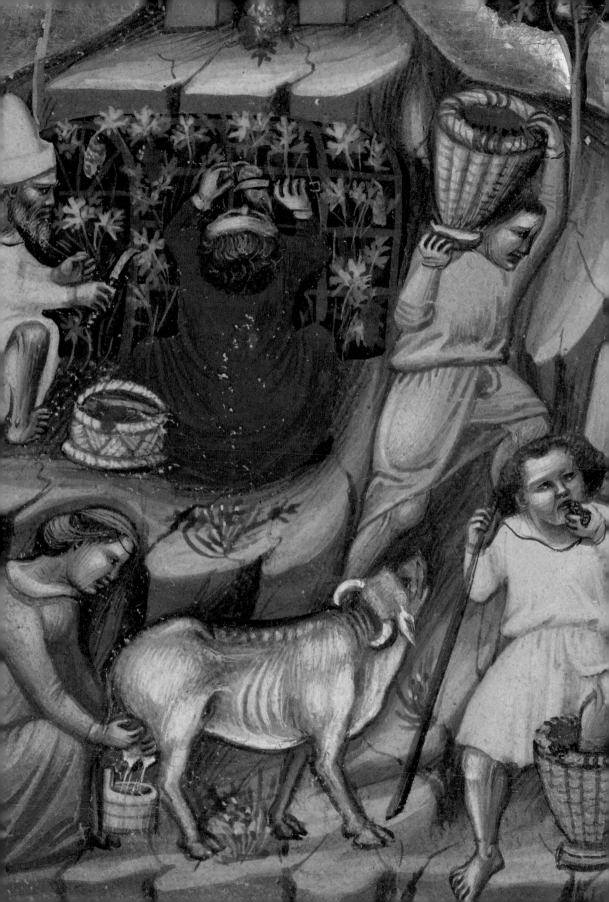

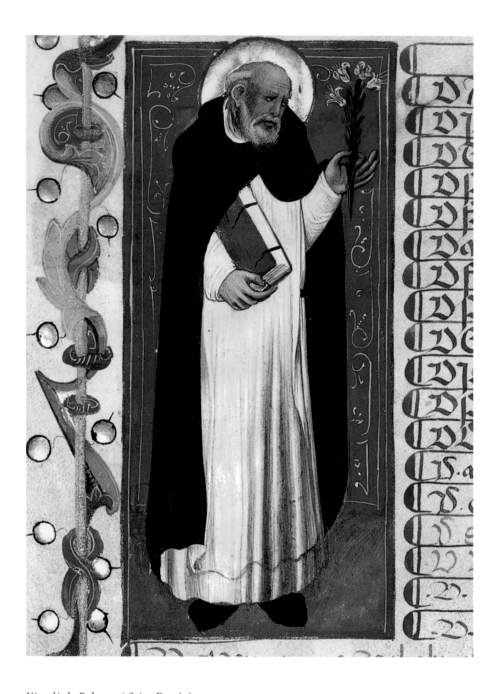

Niccolò da Bologna | Saint Dominic

Leaf from a register of the Shoemakers' Guild, recto (detail)
Bologna, about 1386
Leaf: 35 × 24.5 cm (13¾ × 9⅝ in.)
Ms. 82; 2003.113

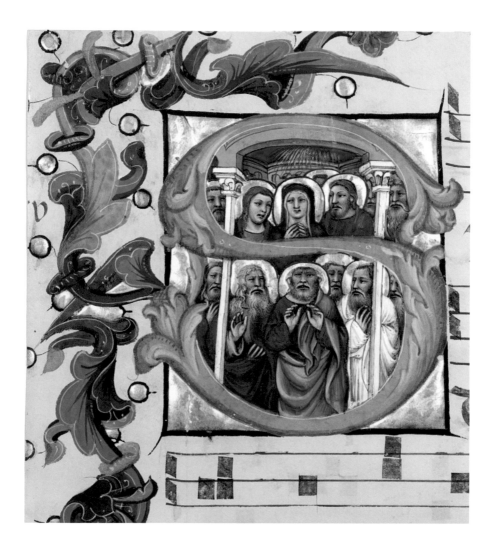

Niccolò da Bologna | Initial S: Pentecost

Cutting from a choir book, recto
Bologna, about 1392–1402
Cutting: 21.6 × 21 cm (8½ × 8¼ in.)
Ms. 86; 2004.48

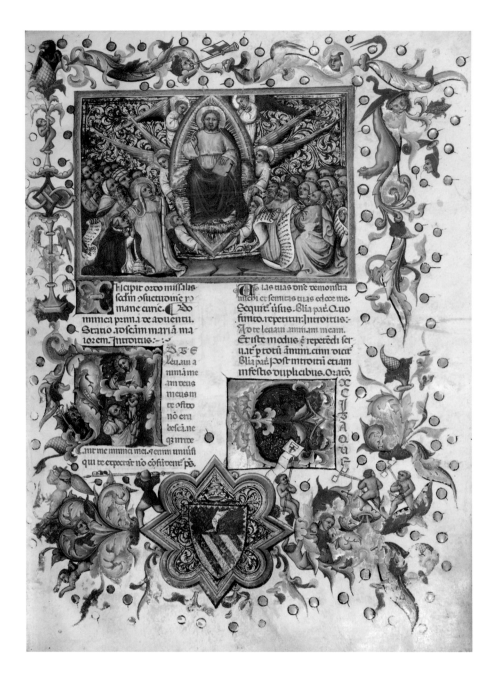

Master of the Brussels Initials | Christ in Majesty; Initial A:
A Man Lifting His Soul to God

Missal, fol. 7
Bologna, between 1389 and 1404
Leaf: 33 × 24 cm (13 × 9⁷⁄₁₆ in.)
Ms. 34; 88.MG.71

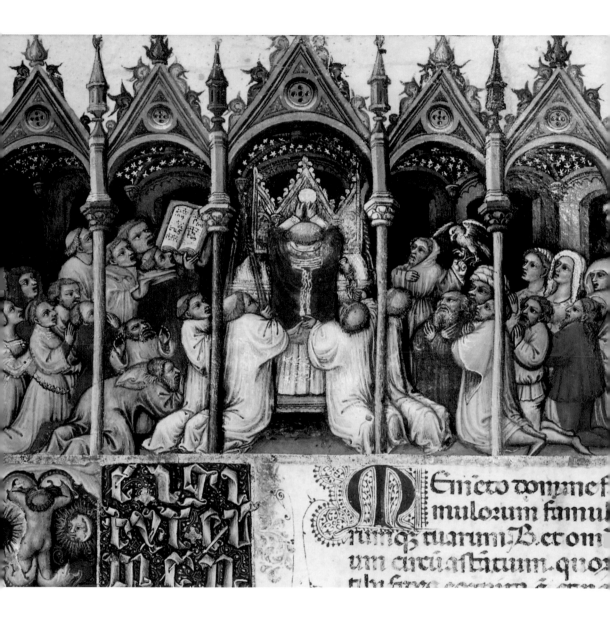

Master of the Brussels Initials | The Elevation of the Host

Missal, fol. 130 (detail)

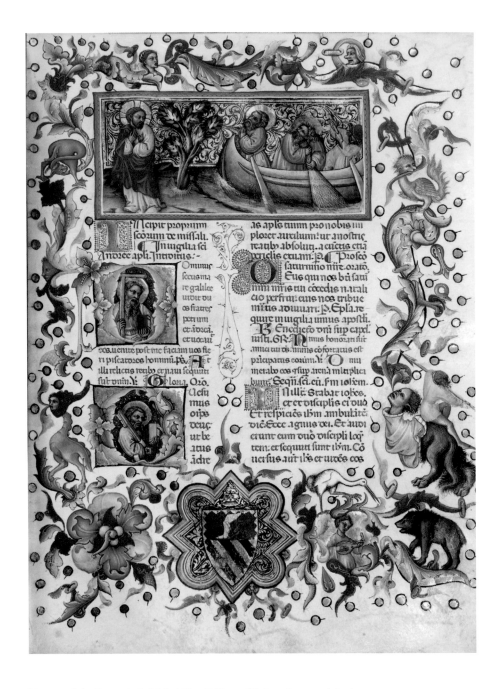

Master of the Brussels Initials | The Calling of Saints Peter and Andrew;
Initial D: Saint Andrew; Initial Q: Saint Peter

Missal, fol. 172a and detail

fortatus est
Omni
nia mltiplica
s̄m iolem.
bat iolies.
plis eı̄ duo
ambulāte
ei. Et audı̄
n̄ıscı̄pli loq̄
n̄t ıb̄m. Cō
uıdēs eos

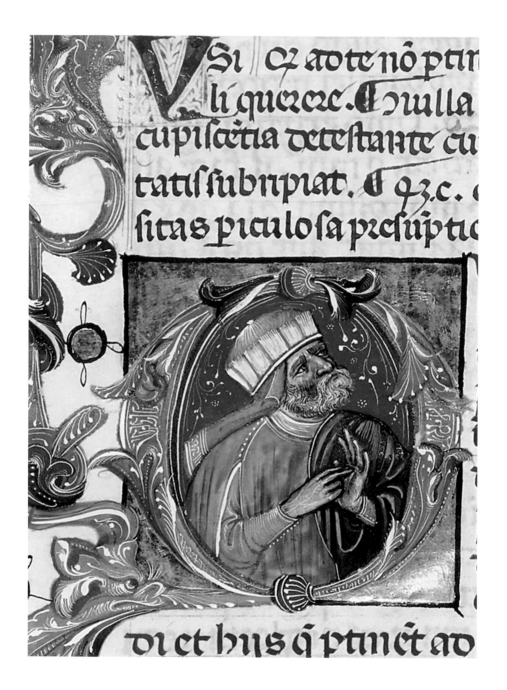

Cristoforo Cortese | Initial Q: Bust Portrait of a Man

Heremias de Montagnone, Compendium
moralium notabilium, *fol. 147 (detail)*
Venice, early fifteenth century
Leaf: 36.8 × 26 cm (14½ × 10¼ in.)
Ms. Ludwig XIV 8; 83.MQ.167

fortatus est
mu
ia mltiplica
sm iolicm.
bat iohcs.
plis ei duo
ambulātē
ei. Et audi
iscipli loq
ī ihm. Cō
uidēs eos

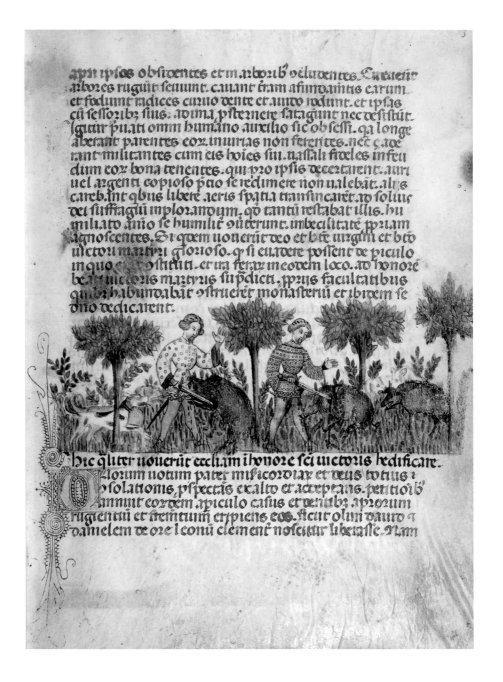

Attributed to Anovelo da Imbonate or His Circle | Aimo and Vermondo Killing Two Wild Boars

Legend of the Venerable Men Aimo
and Vermondo (Legenda Venerabilium
Virorum Aymonis et Vermondi), *fol. 3*
Milan, about 1400
Leaf: 25.6 × 18.4 cm (10¹/₁₆ × 7¼ in.)
Ms. 26; 87.MN.33

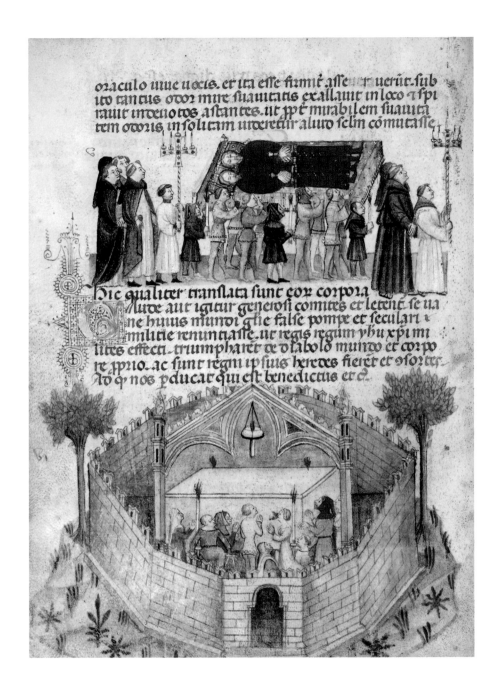

Attributed to Anovelo da Imbonate or His Circle | The Translation of Aimo and Vermondo;
The People of Milan Praying at the Altar Where Aimo and Vermondo Are Buried

Legend of the Venerable Men Aimo
and Vermondo, *fol. 5v*

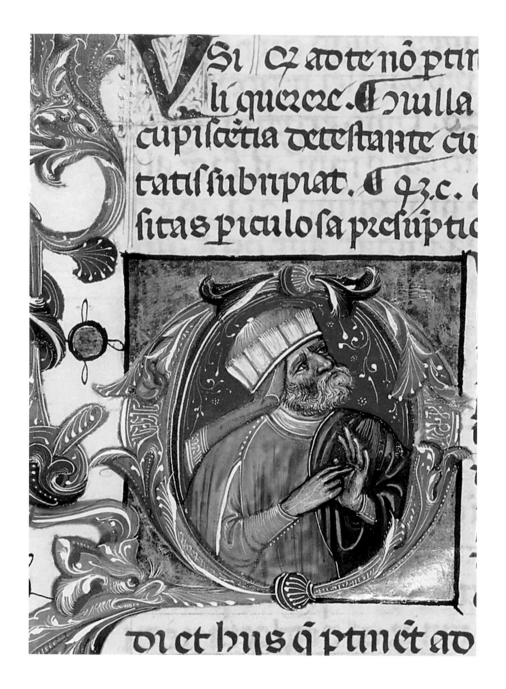

Cristoforo Cortese | Initial Q: Bust Portrait of a Man

Heremias de Montagnone, Compendium
moralium notabilium, *fol. 147 (detail)*
Venice, early fifteenth century
Leaf: 36.8 × 26 cm (14½ × 10¼ in.)
Ms. Ludwig XIV 8; 83.MQ.167

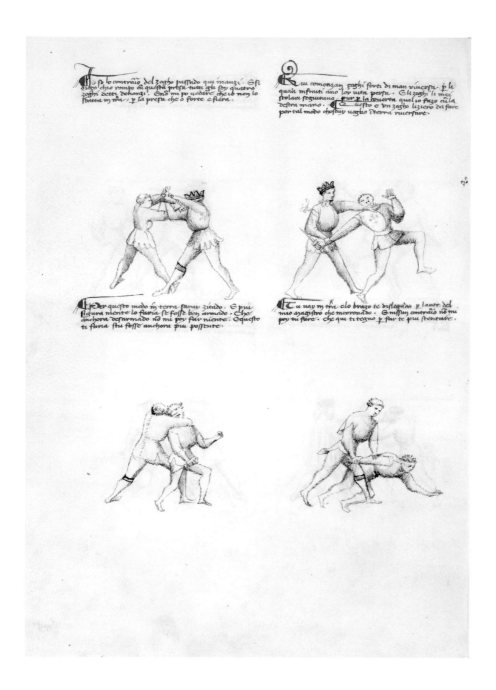

Combat with a Dagger

Fiore Furlan dei Liberti da Premariacco,
The Flower of Battle (Fior di Battaglia),
fol. 13v
Northern Italy, about 1410
Leaf: 27.9 × 20.6 cm (11 × 8⅛ in.)
Ms. Ludwig xv 13; 83.MR.183

37

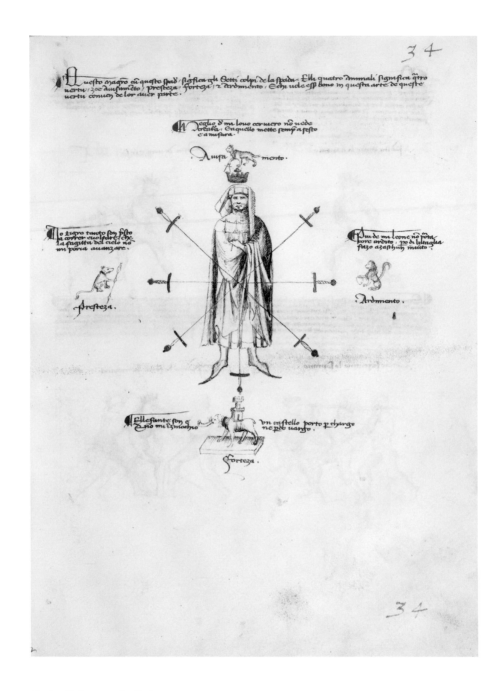

Aiming Points on the Body

Fiore Furlan dei Liberti da Premariacco,
The Flower of Battle, *fol. 32*

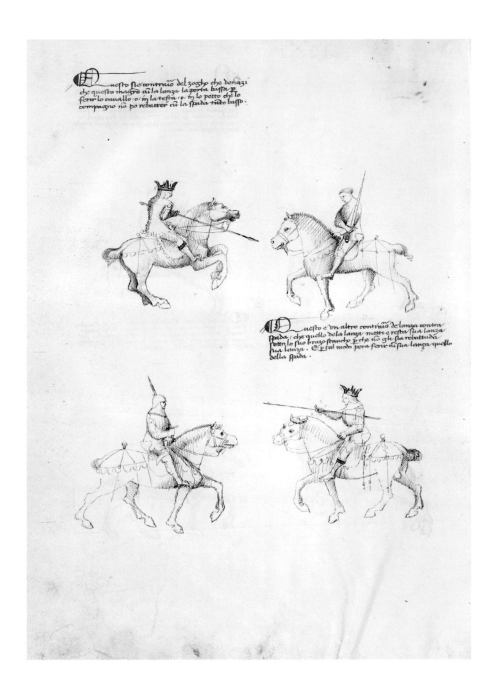

Equestrian Combat with Sword

Fiore Furlan dei Liberti da Premariacco,
The Flower of Battle, *fol. 44v*

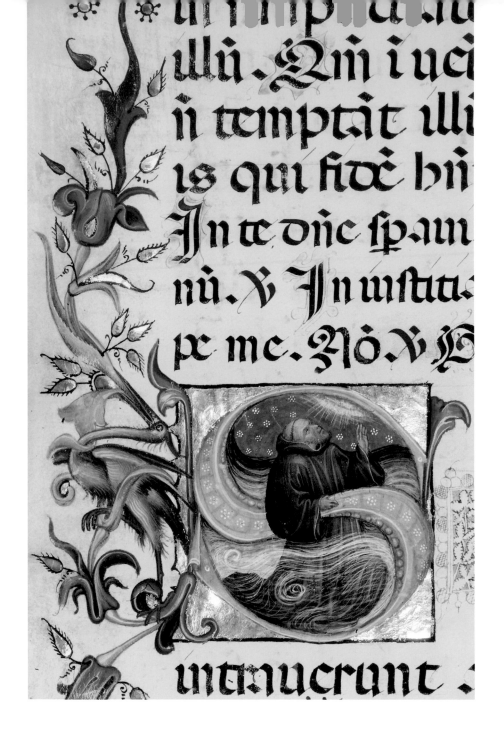

Initial S: Benedictine Monk in a Swirling Sea

Leaves from a noted breviary, leaf 2 (detail)
Northeastern Italy, about 1420
Leaf: 46.5 × 34.6 cm (18⁵⁄₁₆ × 13⁵⁄₈ in.)
Ms. 24; 86.ML.674

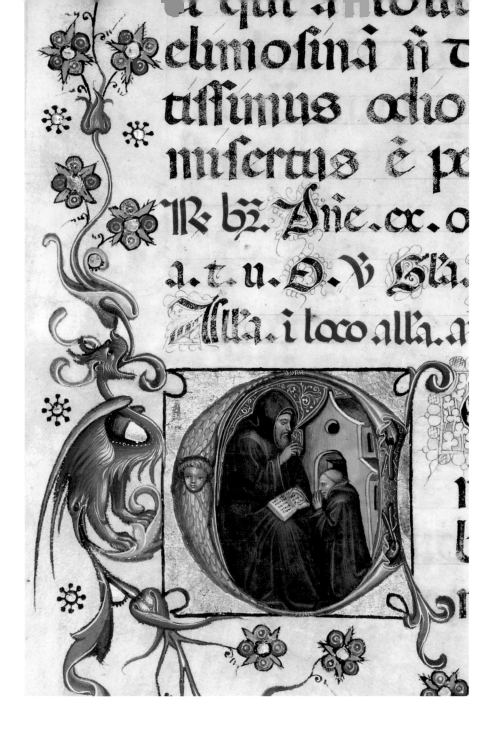

Initial C: Saint Benedict Blessing Maurus

Leaves from a noted breviary, leaf 4 (detail)

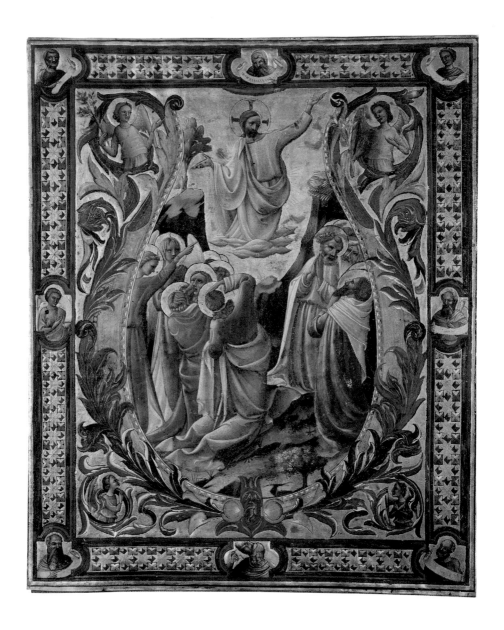

Designed by Lorenzo Monaco; completed perhaps by Zanobi Strozzi
and Battista di Biagio Sanguini | Initial V: The Ascension

Cutting from a gradual, recto
Florence, about 1410 (designed);
about 1431 (completed)
Cutting: 40.2 × 32.4 cm (15¹³⁄₁₆ × 12¾ in.)
Ms. 78; 2003.104

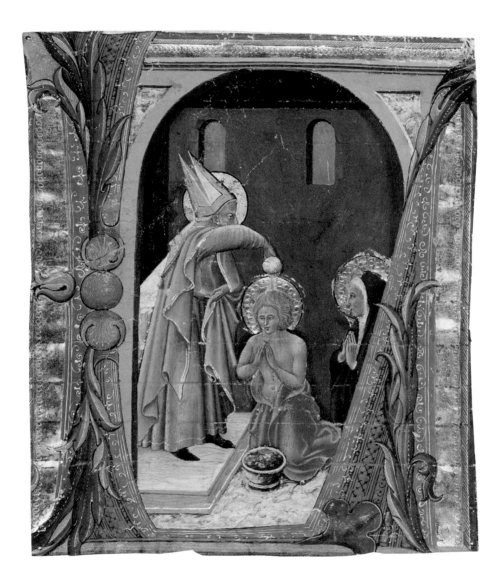

Master of the Osservanza | Initial L: The Baptism of Saint Augustine Witnessed by Saint Monica

Cutting from a choir book, recto
Siena, about 1430
Cutting: 18.7 × 16.2 cm (7⅜ × 6⅜ in.)
Ms. 39; 90.MS.41

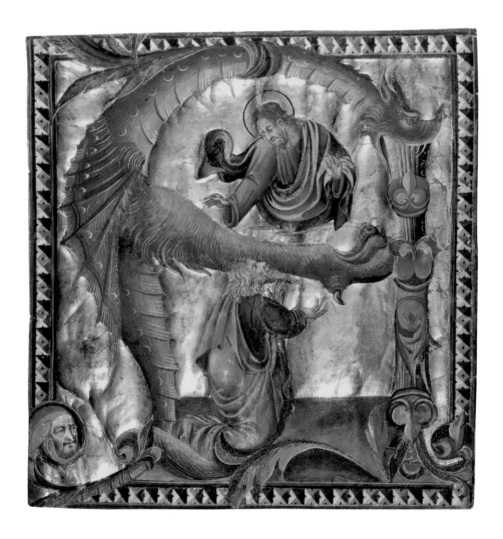

Giovanni di Paolo | Initial A: Christ Appearing to David

Cutting from a gradual, recto
Siena, about 1440
Cutting: 20 × 18.6 cm (7⅞ × 7⁵⁄₁₆ in.)
Ms. 29; 87.MS.133

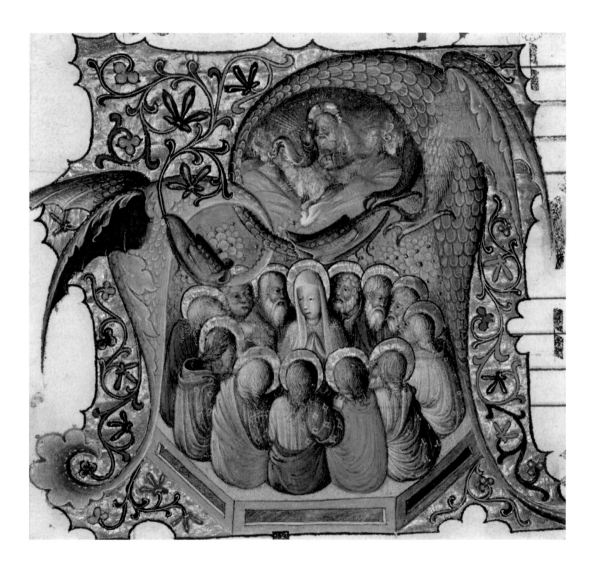

Attributed to Stefano da Verona | Initial A: Pentecost

Cutting from an antiphonal, recto
Lombardy, about 1430–35
Cutting: 11.9 × 12.5 cm (4¹¹⁄₁₆ × 4¹⁵⁄₁₆ in.)
Ms. 95; 2005.28

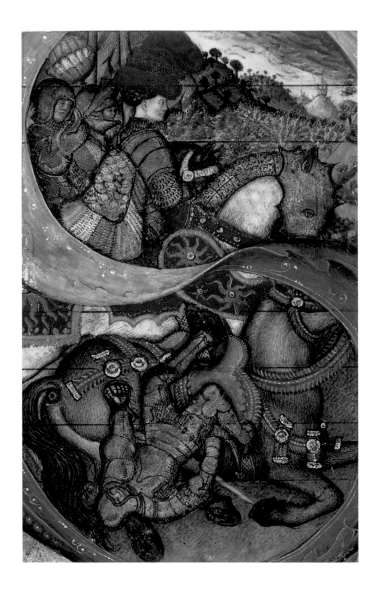

Attributed to Pisanello and the Master of Antiphonal Q
of San Giorgio Maggiore | Initial S: The Conversion of Saint Paul

Cutting from a gradual, verso
Probably northern Italy, about 1440–50
Cutting: 14.1 × 8.9 cm (5⁹⁄₁₆ × 3½ in.)
Ms. 41; 91.MS.5

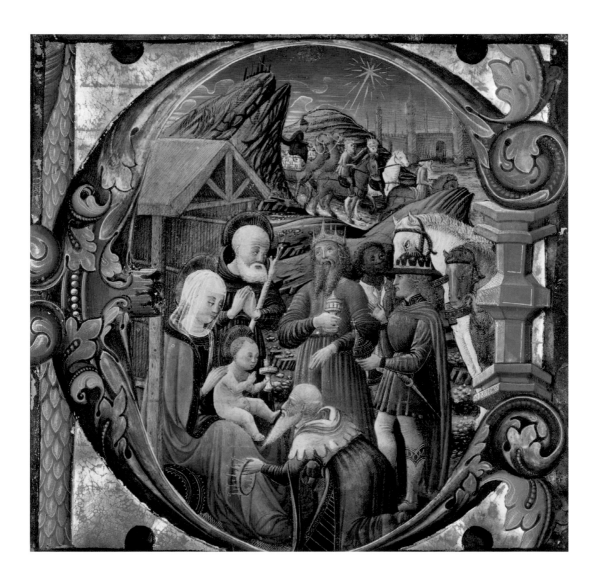

Franco dei Russi | Initial E: The Adoration of the Magi

Cutting from a choir book, recto
The Veneto, 1470s
Cutting: 15 × 15.7 cm (5⅞ × 6³⁄₁₆ in.)
Ms. 83; 2003.114

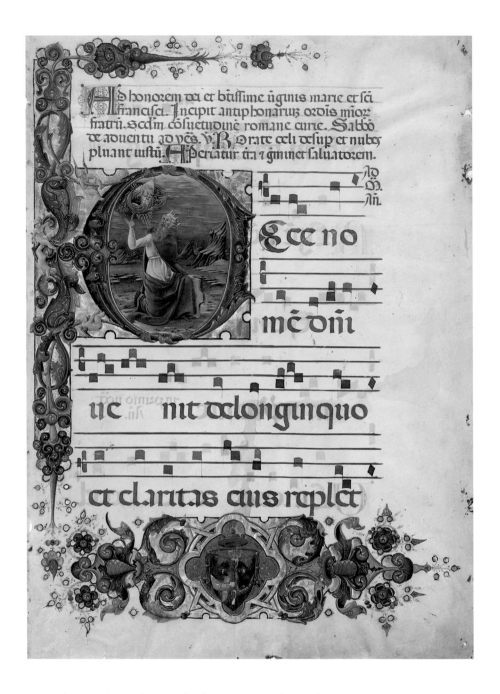

Franco dei Russi | Initial E: David Lifting Up His Soul to God

Leaf from the Antiphonal of Cardinal
Bessarion, recto, and detail
Ferrara, about 1455–61
Leaf: 71.1 × 51.4 cm (28 × 20¼ in.)
Ms. 99; 2007.30

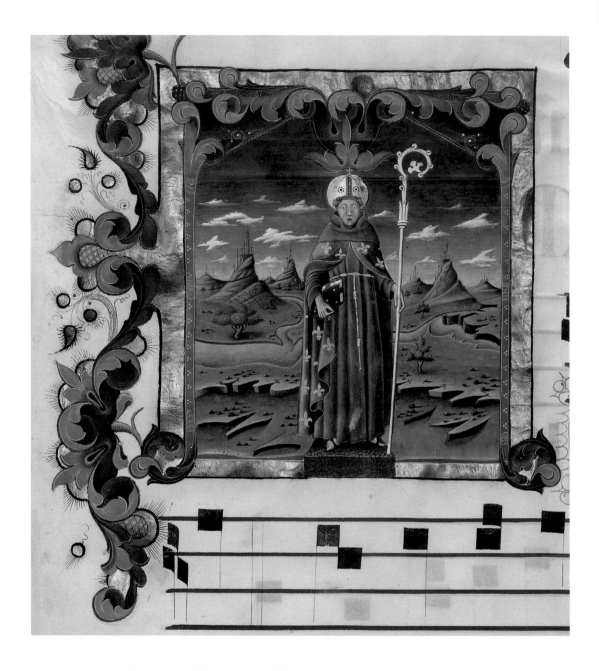

Franco dei Russi | Initial T: Saint Louis of Toulouse

Leaf from the Antiphonal
of Cardinal Bessarion, recto (detail)
Ferrara, about 1453–63
Leaf: 73 × 53.4 cm (28¾ × 21 in.)
Ms. 90; 2005.20

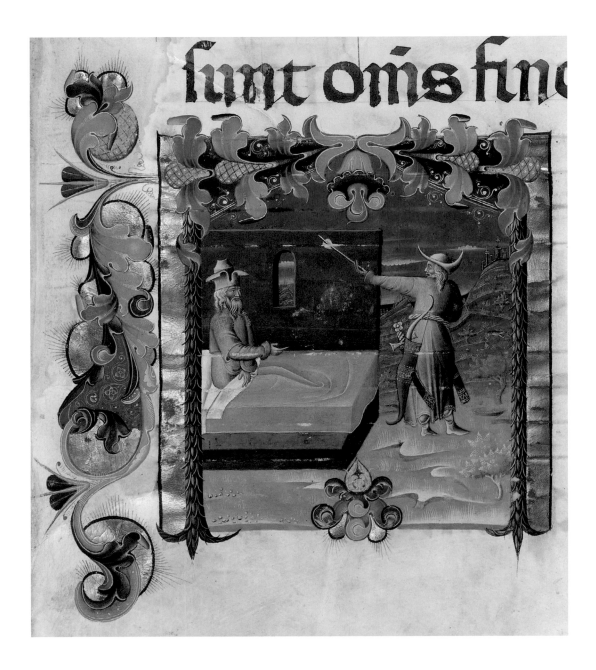

Franco dei Russi | Initial T: Isaac and Esau

Leaf from the Antiphonal of Cardinal
Bassarion, recto (detail)
Ferrara, about 1455–60/63
Leaf: 58.1 × 41.5 cm (22⁷⁄₈ × 16⁵⁄₁₆ in.)
Ms. 98; 2005.38

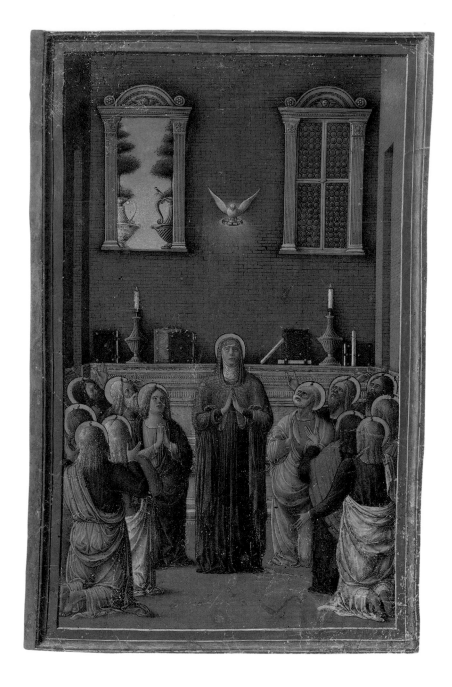

Girolamo da Cremona | Pentecost

Miniature from a devotional or
liturgical manuscript, recto
Probably Mantua, about 1460–70
Cutting: 20.2 × 12.9 cm (7^{15}⁄$_{16}$ × 5^{1}⁄$_{16}$ in.)
Ms. 55; 94.MS.13

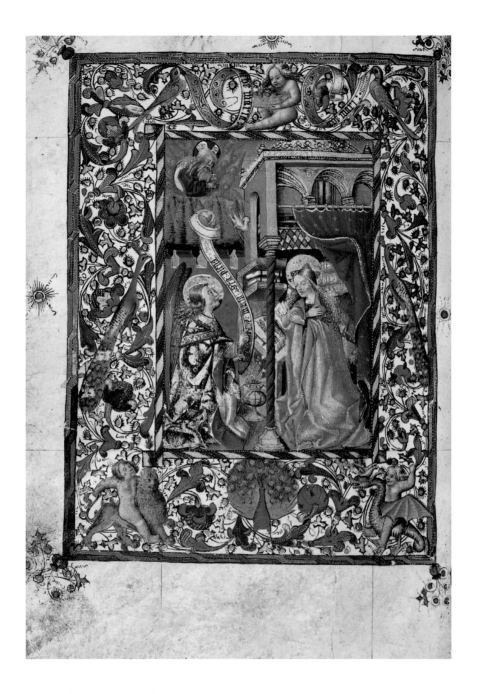

Master of Saint George | The Annunciation

Book of hours, fol. 250v
Naples, about 1460
Leaf: 17.1 × 12.1 cm (6¾ × 4¾ in.)
Ms. Ludwig IX 12; 83.ML.108

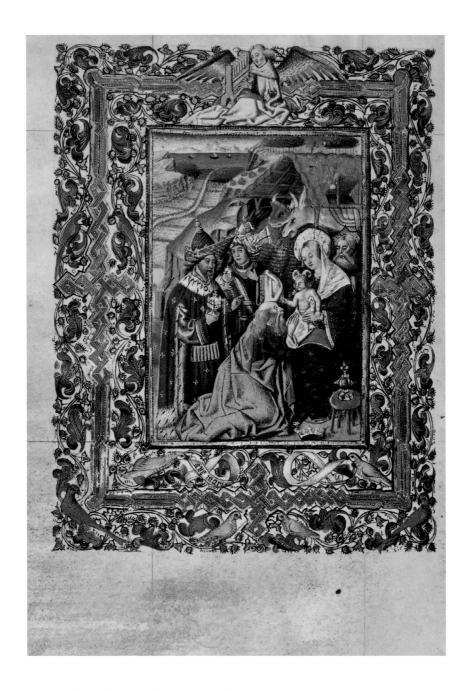

Master of Saint George | The Adoration of the Magi

Book of hours, fol. 256v

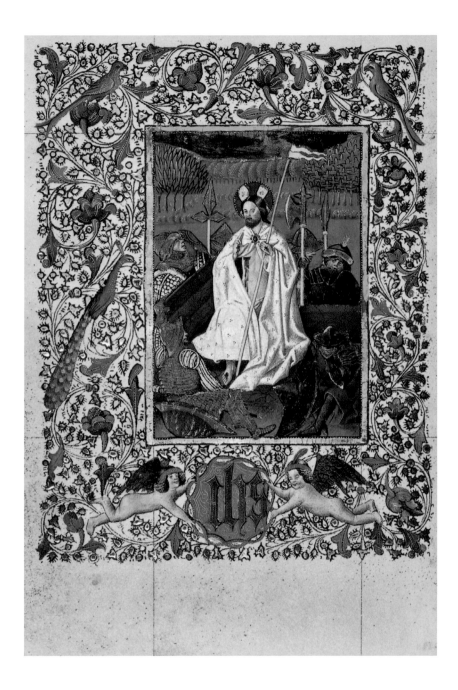

Master of Saint George | The Resurrection

Book of hours, fol. 259v

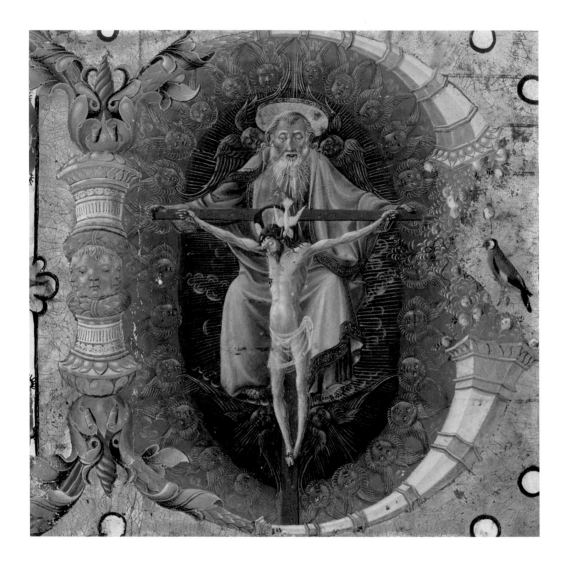

Taddeo Crivelli | Initial B: The Trinity

Cutting from a gradual, recto, and detail
Ferrara, about 1460–70
Cutting: 16 × 16 cm (6⁵⁄₁₆ × 6⁵⁄₁₆ in.)
Ms. 88; 2005.2

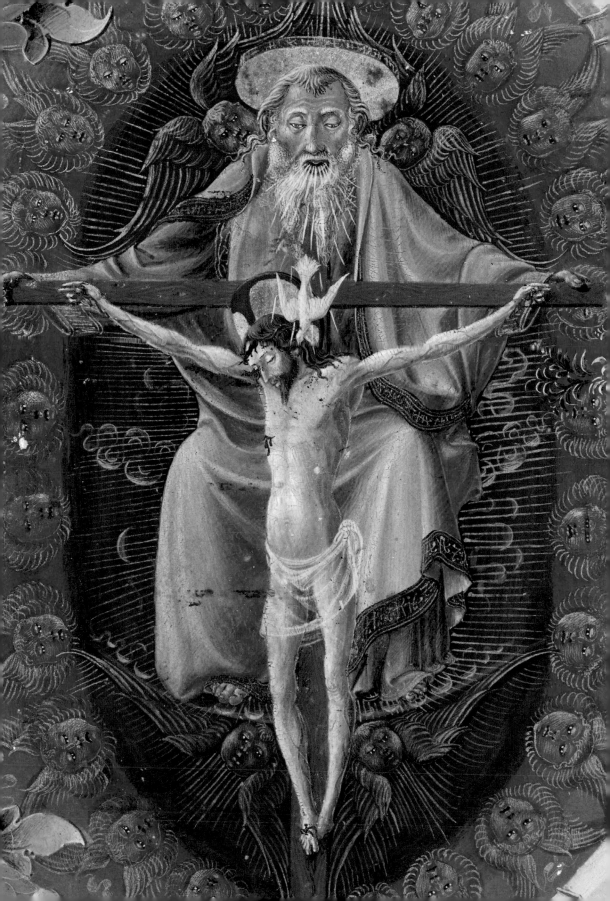

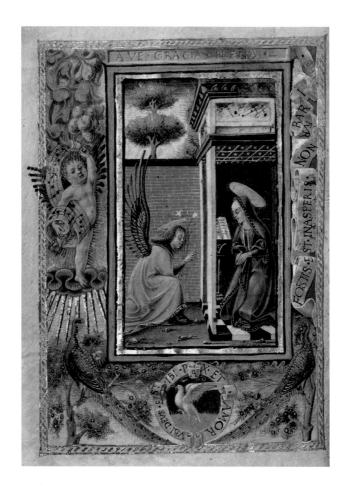

Taddeo Crivelli | The Annunciation

Gualenghi-d'Este Hours, fol. 3v
Ferrara, about 1469
Leaf: 10.8 × 7.9 cm (4¼ × 3⅛ in.)
Ms. Ludwig IX 13; 83.ML.109

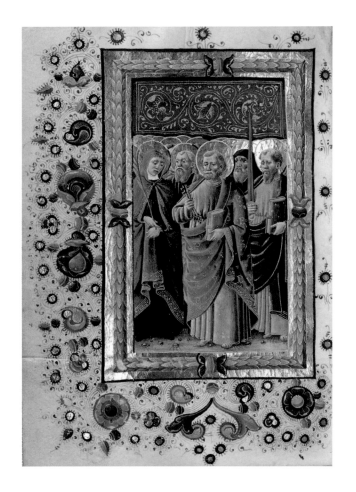

Guglielmo Giraldi | All Saints

Gualenghi-d'Este Hours, fol. 159v

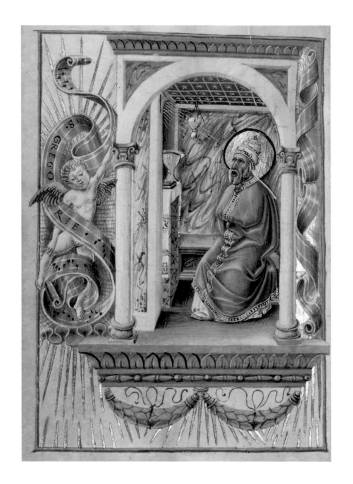

Taddeo Crivelli | Saint Gregory

Gualenghi-d'Este Hours, fol. 172v

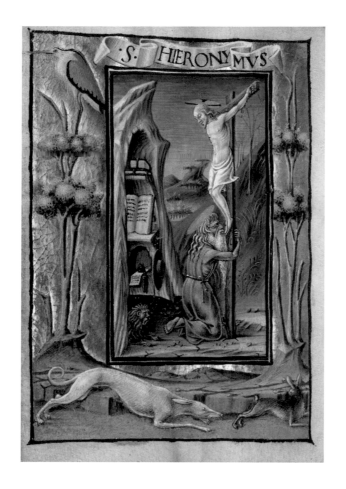

Taddeo Crivelli | Saint Jerome in the Desert

Gualenghi-d'Este Hours, fol. 174v

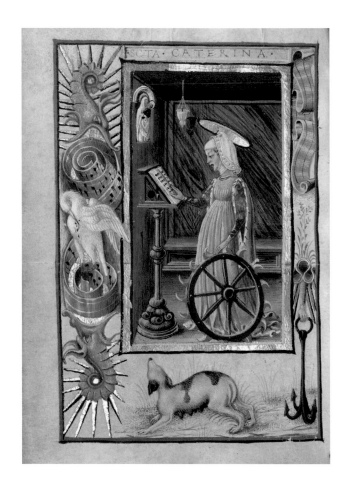

Taddeo Crivelli | Saint Catherine of Alexandria

Gualenghi-d'Este Hours, fol. 187v

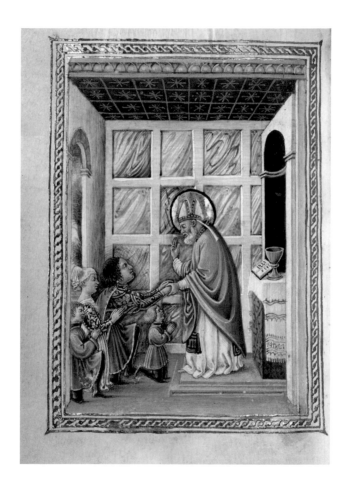

Taddeo Crivelli | Saint Bellinus Celebrating Mass with Andrea Gualengo,
Orsina d'Este, and Children

Gualenghi-d'Este Hours, fol. 199v

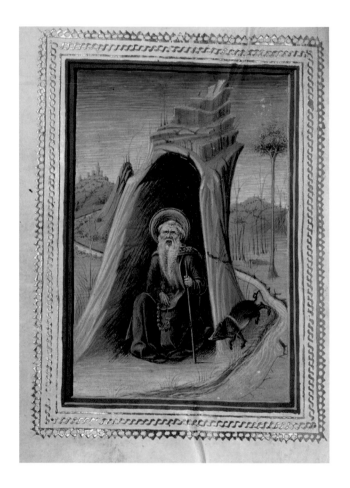

Taddeo Crivelli | Saint Anthony Abbot

Gualenghi-d'Este Hours, fol. 204v

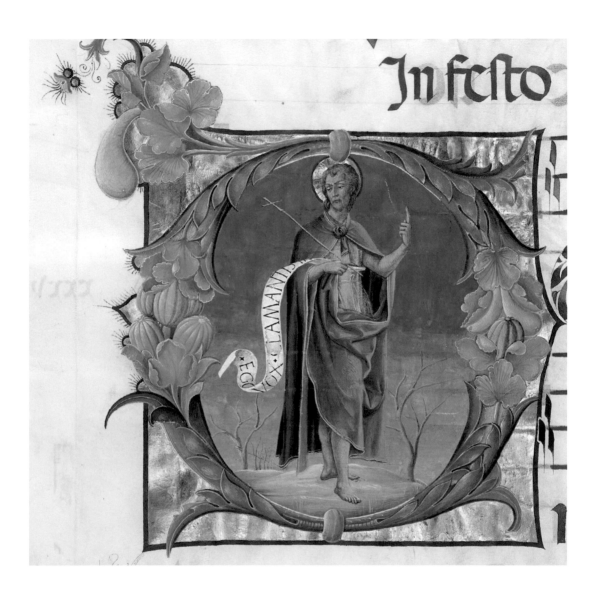

Attributed to Cosmè Tura | Initial D: Saint John the Baptist

Cutting from a gradual, verso (detail)
Ferrara, about 1470–80
Cutting: 35 × 29.8 cm (13¾ × 11¾ in.)
Ms. 94; 2005.27

Decorated Text Page

Lactantius, Divine Institutions (*Divinae institutiones*) *and other texts, fol. 1v*
Florence, about 1456
Leaf: 32.9 × 22.1 cm (12¹⁵⁄₁₆ × 8¹¹⁄₁₆ in.)
Ms. Ludwig XI 1; 83.MN.120

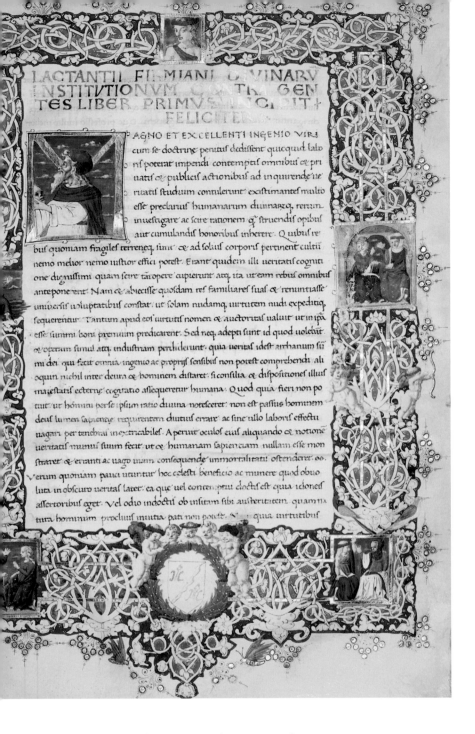

Ser Ricciardo di Nanni | Initial M: Portrait of Lactantius

Fol. 2

Decorated Text Page

Gaius Julius Caesar, Commentary on
the Gallic Wars (De Bello Gallico) *and
other texts, fol. 1v*
Florence, about 1460–70
Leaf: 32.7 × 23 cm (12⅞ × 9¹/₁₆ in.)
Ms. Ludwig XIII 8; 83.MP.151

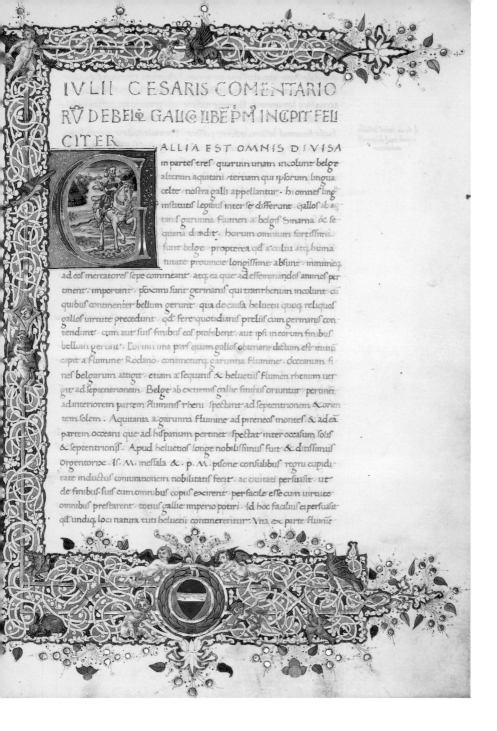

Attributed to Francesco d'Antonio del Chierico | Initial G: Julius Caesar on Horseback

Fol. 2

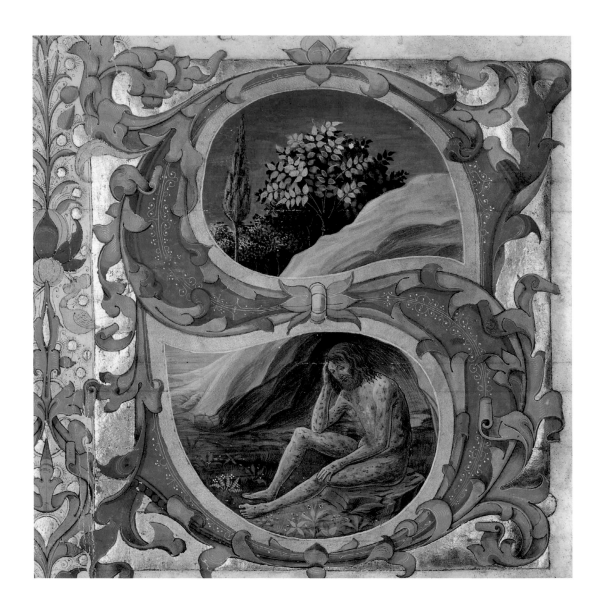

Francesco d'Antonio del Chierico | Initial S: Job

Cutting from a choir book, recto (detail)
Florence, third quarter of
the fifteenth century
Cutting: 21 × 19 cm (8¼ × 7½ in.)
Ms. 74; 2003.88

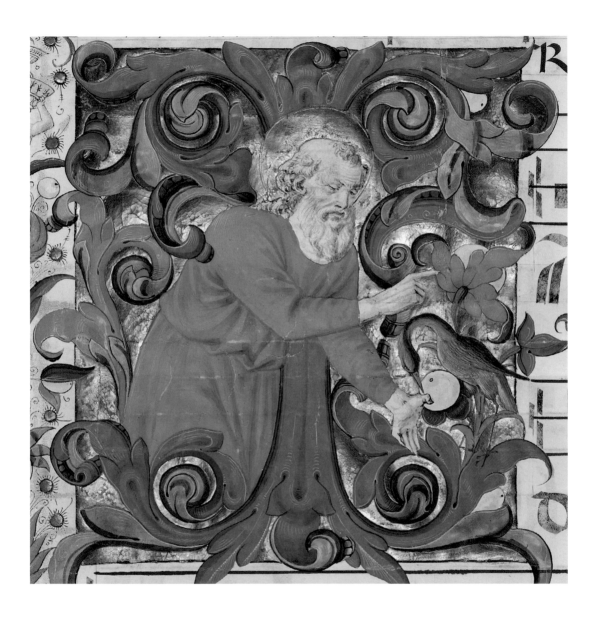

Francesco d'Antonio del Chierico | Initial I: God the Father Blessing

Bifolium from an antiphonal, leaf 2v
(detail)
Florence, early 1460s
Leaf: 57.7 × 40 cm (22^{11}/$_{16}$ × 15¾ in.)
Ms. 84; 2003.115

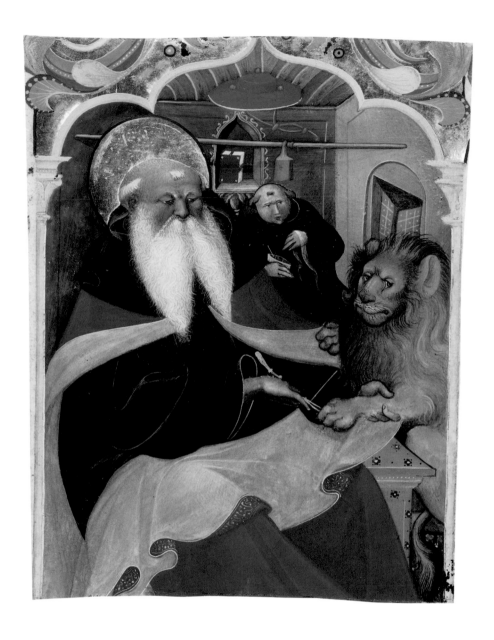

Master of the Murano Gradual | Saint Jerome Extracting a Thorn from a Lion's Paw

Cutting from a gradual, recto
Venice, about 1425–50
Cutting: 21 × 16.5 cm (8¼ × 6½ in.)
Ms. 106; 2010.21

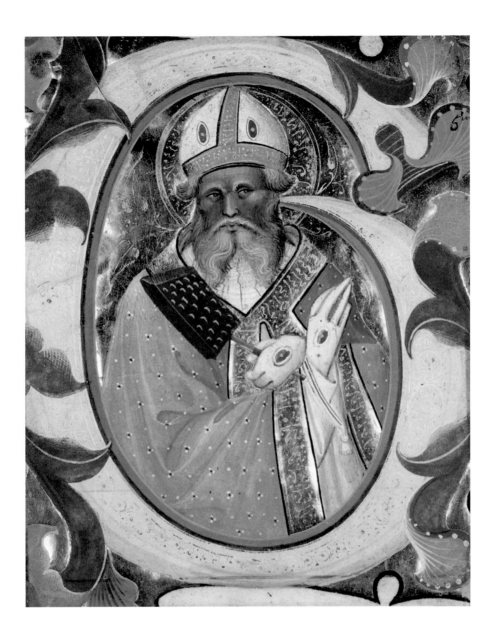

Master of the Murano Gradual | Initial G: Saint Blaise

Cutting from a gradual, recto
Venice, about 1450–60
Cutting: 15.7 × 12 cm (6³⁄₁₆ × 4¾ in.)
Ms. 73; 2003.87

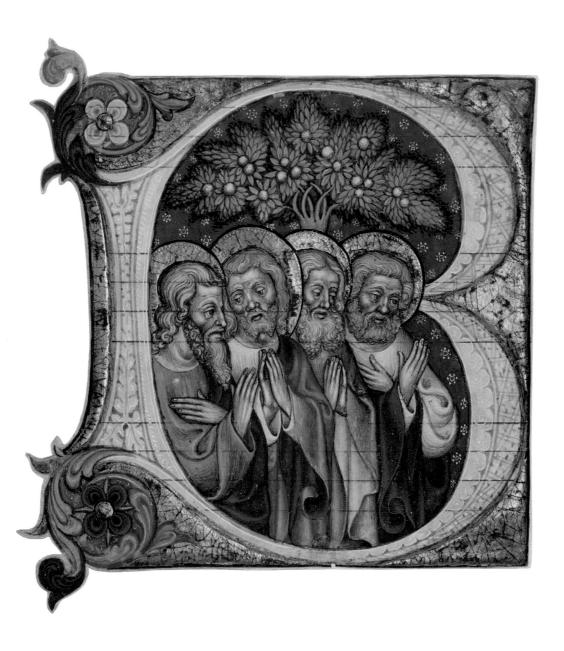

Olivetan Master | Initial B: Four Saints

Cutting from a choir book, recto
Lombardy, about 1450
Cutting: 20.6 × 19.1 cm (8⅛ × 7½ in.)
Ms. 75; 2003.89

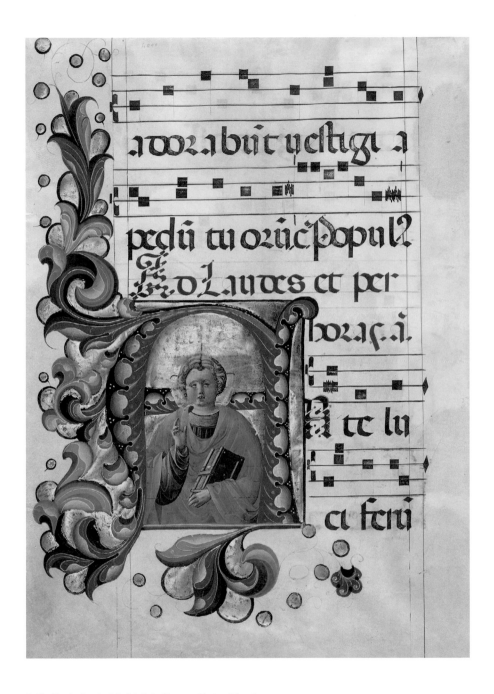

Belbello da Pavia | Initial A: Young Christ Blessing

Leaf from Antiphonal P of
San Giorgio Maggiore, verso
Venice, about 1467–70
Leaf: 56.2 × 40.7 cm (22⅛ × 16 in.)
Ms. 96; 2005.29

Bartolomeo Gossi da Gallarate | Initial A: The Women at the Tomb

Cutting from an antiphonal, verso
Lombardy, about 1465
Cutting: 15.1 × 14.6 cm ($5^{15}/_{16}$ × $5^{3}/_{4}$ in.)
Ms. 47; 93.MS.2

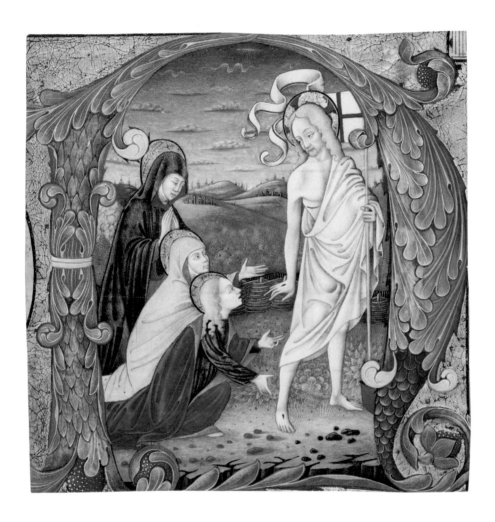

Bartolomeo Gossi da Gallarate | Initial N: Christ Appearing to the Marys

Cutting from an antiphonal, recto
Lombardy, about 1465
Cutting: 15.1 × 14.6 cm (5¹⁵⁄₁₆ × 5¾ in.)
Ms. 49; 93.MS.8

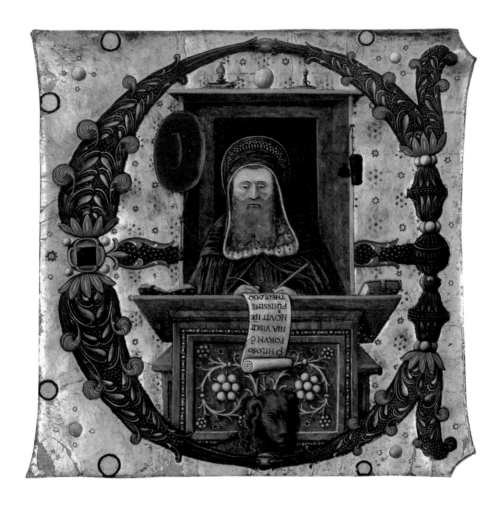

Attributed to the Master of the Birago Hours | Initial E: Saint Jerome in His Study

Cutting from a choir book, recto
Lombardy, about 1470–80
Cutting: 14.5 × 14 cm (5¹¹⁄₁₆ × 5½ in.)
Ms. 76; 2003.90

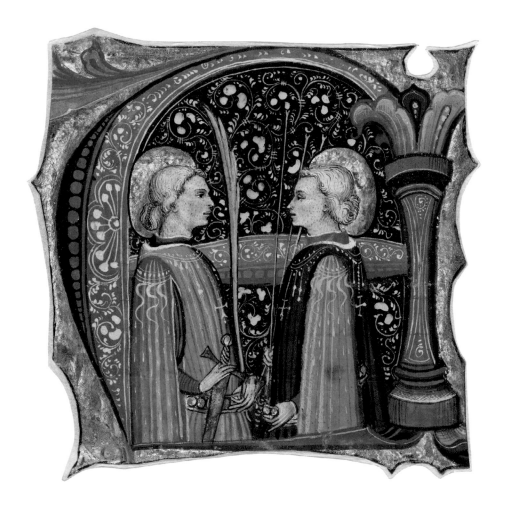

Frate Nebridio | Initial A: Saints Maurus and Theofredus

Cutting from an antiphonal, recto
Cremona, about 1460–80
Cutting: 11.5 × 11.5 cm (4½ × 4½ in.)
Ms. 91; 2005.21

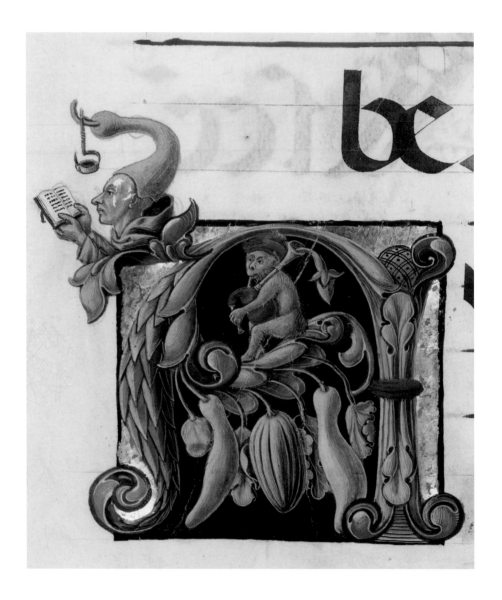

Inhabited Initial A

Gradual, fol. 148v (detail)
Northern Italy, about 1460–80
Leaf: 60.3 × 44 cm (23¾ × 17⁵⁄₁₆ in.)
Ms. Ludwig VI 2; 83.MH.85

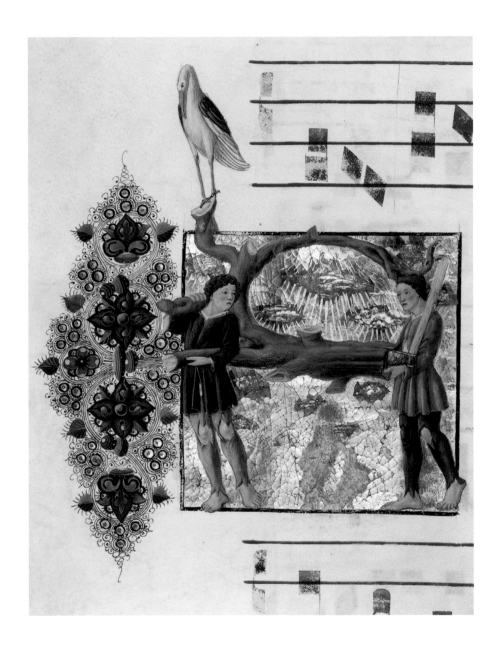

Inhabited Initial A

Gradual, fol. 160v (detail)

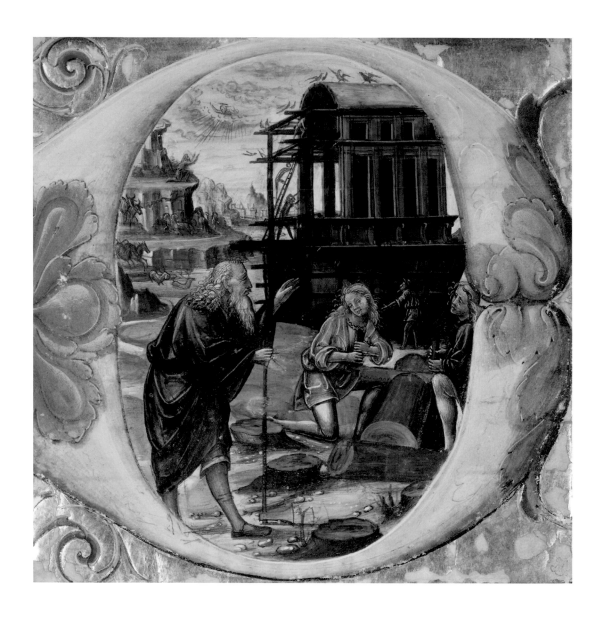

Master B.F. | Initial D: Noah Directing the Construction of the Ark

Cutting from an antiphonal, recto
Lombardy, about 1490–1510
Cutting: 16.8 × 17 cm (6⁵⁄₈ × 6¹¹⁄₁₆ in.)
Ms. 56; 94.MS.18

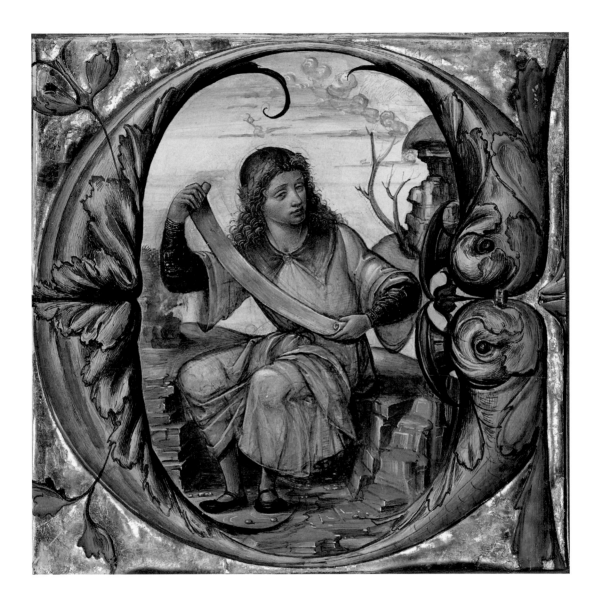

Master B.F. | Initial E: Saint John the Evangelist

Cutting from an antiphonal, recto
Lombardy, early sixteenth century
Cutting: 16.5 × 16.5 cm (6½ × 6½ in.)
Ms. 104; 2009.51

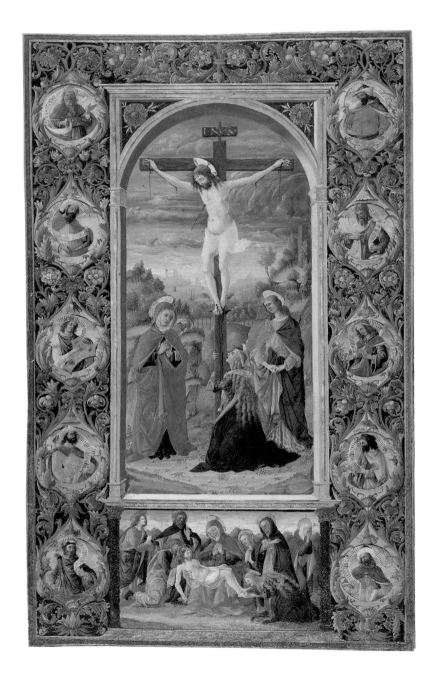

Giuliano Amadei | The Crucifixion

Miniature from the Missal of Innocent VIII, recto
Rome, between 1484 and 1492
Leaf: 39.7 × 24.1 cm (15⅝ × 9½ in.)
Ms. 110; 2012.2

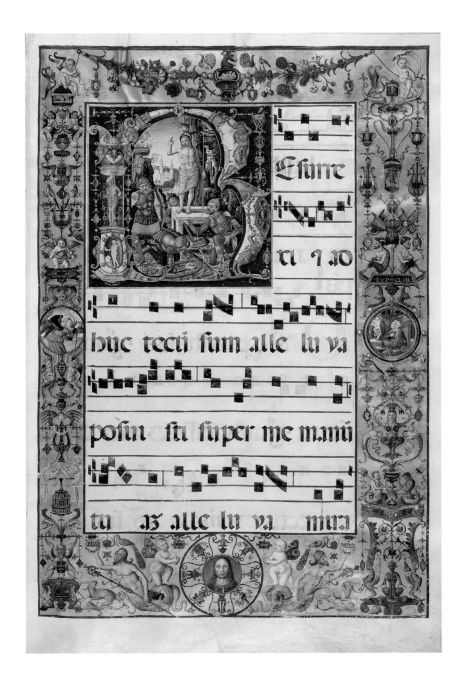

Antonio da Monza | Initial R: The Resurrection

Gradual, fol. 16
Rome, late fifteenth or early
sixteenth century
Leaf: 64.1 × 43.5 cm (25¼ × 17⅛ in.)
Ms. Ludwig VI 3; 83.MH.86

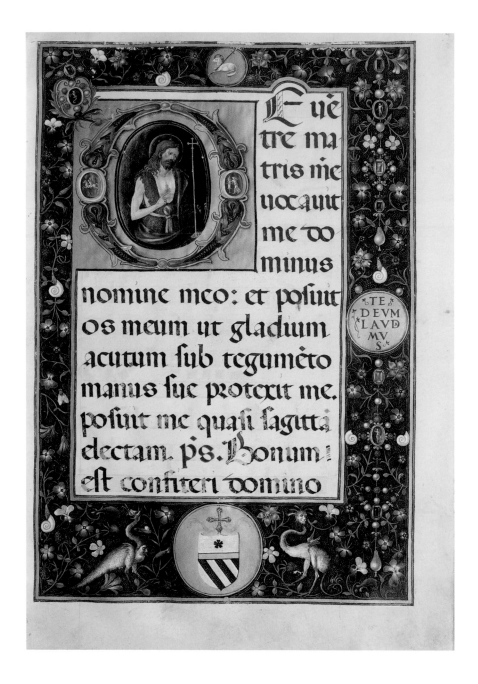

Matteo da Milano | Initial O: Saint John the Baptist

Missal, fol. 4
Rome, about 1520
Leaf: 33.6 × 23.4 cm (13¼ × 9¼ in.)
Ms. 87; 2004.65

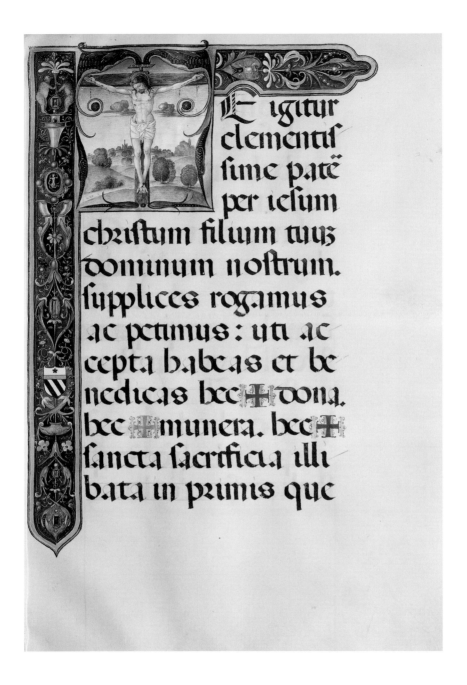

Te igitur
clementis
sime pate
per iesum
christum filium tuuz
dominum nostrum.
supplices rogamus
ac petimus: uti ac
cepta habeas et be
nedicas hec ✠ dona.
hec ✠ munera. hec ✠
sancta sacrificia illi
bata in primis que

Matteo da Milano | Initial T: The Crucifixion

Missal, fol. 27

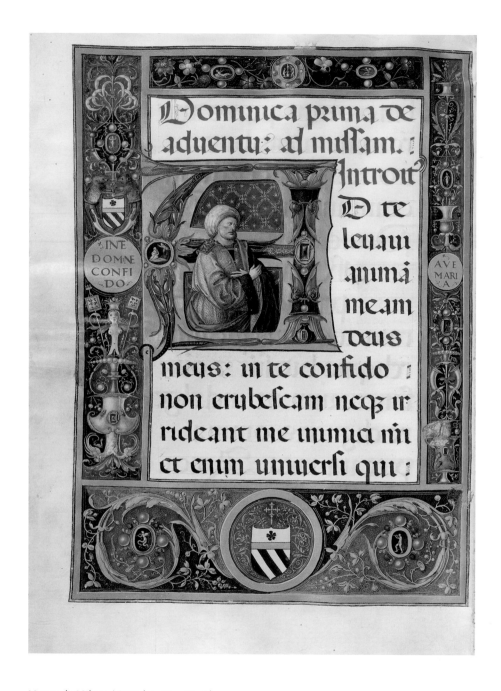

Matteo da Milano | Initial A: King David

Missal, fol. 52v and detail

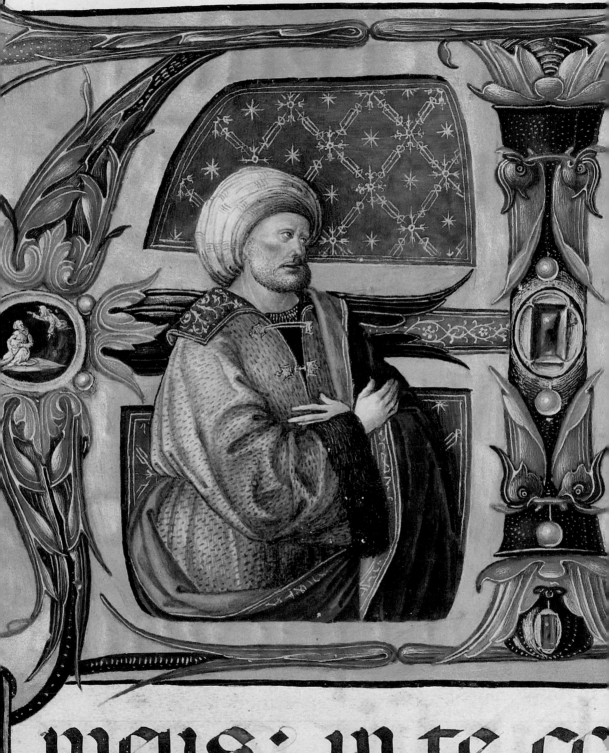

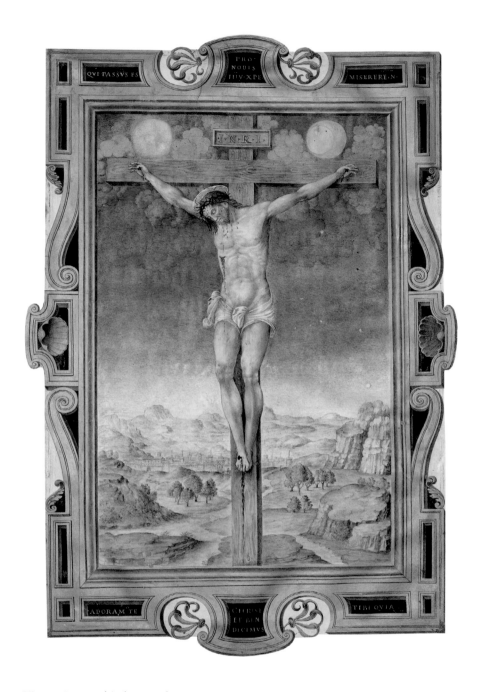

Vincent Raymond | The Crucifixion

Miniature from a missal, recto
Rome, about 1545
Detached miniature: 37.2 × 26 cm
(14⅝ × 10¼ in.)
Ms. 85; 2003.116

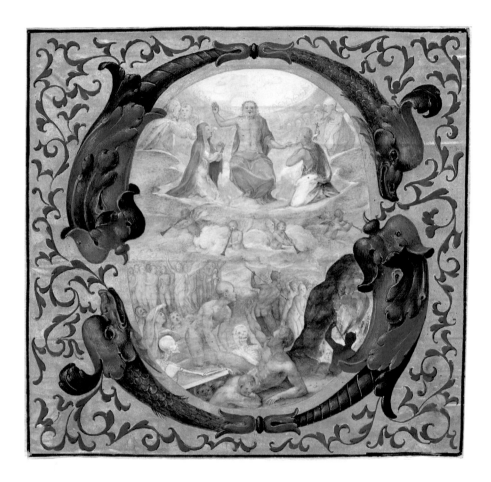

Roman School | Initial S: The Last Judgment

Cutting from a gradual, verso
Rome, about 1567–72
Cutting: 15.6 × 16 cm (6⅛ × 6⁵⁄₁₆ in.)
Ms. 92; 2005.22

© 2005 J. Paul Getty Trust
Second edition 2015

Published by the J. Paul Getty Museum, Los Angeles
Getty Publications
1200 Getty Center Drive, Suite 500
Los Angeles, California 90049-1682

Elizabeth S. G. Nicholson and Ruth Evans Lane, *Project Editors*
Miki Bird, *Manuscript Editor*
Jeffrey Cohen, *Designer*
Amita Molloy, *Production*

Printed in Hong Kong

Library of Congress Cataloging-in-Publication Data
Kren, Thomas, 1950– author.
 Italian illuminated manuscripts in the J. Paul Getty Museum / Thomas Kren,
Kurt Barstow. — Second edition.
 pages cm
 ISBN 978-1-60606-436-8 (pbk.) — ISBN 1-60606-436-3 (pbk.)
 1. J. Paul Getty Museum. 2. Illumination of books and manuscripts, Italian.
3. Illumination of books and manuscripts, Medieval—Italy. 4. Illumination of books
and manuscripts, Renaissance—Italy. 5. Illumination of books and manuscripts—
California—Los Angeles. I. Barstow, Kurt, 1965– author. II. J. Paul Getty Museum,
issuing body. III. Title.
 ND3159.J27 2015
 745.6'7094507479494—dc23
 2014023619

FRONT COVER: Master B.F., Initial E: Saint John the Evangelist (detail, plate p. 83)
BACK COVER: Master of the Murano Gradual, Saint Jerome Extracting a Thorn
from a Lion's Paw (detail, plate p. 72)
FRONT PANEL: The Vision of Zechariah (plate p. 21)
BACK PANEL: The Assassination of Sennacherib (plate p. 20)
FRONTISPIECE: Antonio da Monza, Initial R: The Resurrection (detail, plate p. 85)
PAGE IV: Frate Nebridio, Initial A: Saints Maurus and Theofredus (detail, plate p. 79)
PAGE VI: Attributed to Pisanello and the Master of Antiphonal Q
of San Giorgio Maggiore, Initial S: The Conversion of Saint Paul (detail, plate p. 46)
PAGE IX: Attributed to Stefano da Verona, Initial A: Pentecost (detail, plate p. 45)
PAGE XV: Master of the Dominican Effigies, Pentecost (detail, plate p. 23)
PAGE 92: Taddeo Crivelli, Saint Catherine of Alexandria (detail, plate p. 62)